SURREALIST PAINTING

SURREALIST PAINTING

Simon Wilson

Phaidon Press Limited
Regent's Wharf, All Saints Street, London N1 9PA

Phaidon Press Inc.
180 Varick Street, New York, NY 10014

www.phaidon.com

First published 1975
Second edition, revised and enlarged, 1982
Reprinted 1989
Third edition 1991
Reprinted 1993, 1994, 1995, 1998, 1999, 2001
© 1975, 1982, 1991 Phaidon Press Limited

ISBN 0 7148 2722 3

A CIP catalogue record for this book is available from
the British Library

Printed in Singapore

The publishers have endeavoured to credit all known persons holding
copyright or reproduction rights for the illustrations in this book.
Works by Paul Nash are reproduced by courtesy of the Paul Nash
Trustees. Thanks are also due for permission to reproduce the
following photographs: Plate 7 reproduced by courtesy of the Pierre
Matisse Gallery; Plates 8, 18, 21 and 28 reproduced by courtesy of the
Edward James Foundation. Plate 42 © the Roland Penrose Estate.

Note: All dimensions of works are given height before width.

Cover illustrations:
Front: RENÉ MAGRITTE, *La baigneuse du clair au sombre*, 1935,
private collection
Back: SALVADOR DALI: *Sleep*, 1937 (Plate 28)

Surrealist Painting

Surrealism was a movement in modern art born in 1924 out of the ashes of Dada. It was essentially a continuation of Dada, many of the Dadaists becoming members of the Surrealist group when it formed in Paris in October 1924. The official existence of the group was proclaimed by the publication of the *Manifesto of Surrealism* written by André Breton, Surrealism's founder, its leader and until his death in 1966 the guardian of its doctrinal purity. Dada and Surrealism were both the result of a far-reaching and wide-spread revolt by artists of all kinds against the condition of western society as it was at the start of the twentieth century. This revolt was given a focus by the advent of the First World War (Dada began in Zurich in 1916). A civilization that could perpetrate such an atrocity on such a scale appeared totally discredited in the eyes of men of sensibility, as did the optimistic rationalist and materialist philosophies on which it was based. The great German Dadaist and Surrealist Max Ernst later said ' . . . Dada was a rebellious upsurge of vital energy and rage; it resulted from the absurdity, the whole immense *Schweinerei*, of that imbecilic war. We young people came back from the war in a state of stupefaction, and our rage had to find expression somehow or other. This it did quite naturally through attacks on the foundations of the civilization responsible for the war . . . our enthusiasm encompassed total revolution' (cited by Uwe M. Schneede in *The Essential Max Ernst*, 1972).

This disgust with our civilization naturally extended to its art. However it is important to understand that Dada was not really anti-art as is often thought; quite the contrary, the Dadaists fervently believed in art as the repository and expression of humane and true civilized values. Believing this they naturally set out to purge existing art and create new and valid forms. Their attitude was perfectly encapsulated by the Dada artist Jean Arp when he wrote: 'Uninterested in the slaughter-house of the world war, we turned to the fine arts. While the thunder of the batteries rumbled in the distance we collaged, we recited, we wrote poetry, we sang with all our soul. We searched for a fundamental art that would, we thought, save mankind from the furious folly of these times' (Jean Arp, *Dadaland*). In the *Manifesto of Surrealism* André Breton wrote: 'We are still living under the rule of logic . . . The absolute rationalism which remains in fashion allows the consideration of facts relating only narrowly to our experience . . . Under the banner of civilization, under the pretext of progress we have managed to banish from the mind anything which could be accused, rightly or wrongly, of being superstition or fantasy, and to banish also any method of seeking the truth which does not conform to tradition.'

Change, however, was beginning to take place and, stated Breton: 'All credit for this must go to the discoveries of Freud. On the evidence of these discoveries a current of opinion is at last developing which will enable the explorer of the human mind to extend his investigations much further . . . *Perhaps the imagination is on the verge of recovering its rights*. If the depths of the mind harbour strange forces capable either of reinforcing or of combating those on the surface *then it is our greatest interest to capture them* . . . ' This then was the Surrealist programme, to tap the creative and imaginative forces of the mind at their source in the unconscious and, it may be suggested, through the increase in self-knowledge achieved by confronting people with their real nature, to change society.

It may also be said that it is precisely the extent to which Surrealism, through its undoubtedly far-reaching influence on literature, theatre and the cinema in addition to the arts of painting, drawing and sculpture, has revealed and made familiar to us the world of

the unconscious that constitutes the movement's significance. Surrealism, in all its forms, it may be argued, has been the means by which the discoveries of pyscho-analysis have been brought to a wide public and built into the very fabric of society. It may be added that bringing the public face to face with the unconscious for the first time was bound to produce a shock. The Surrealists tended to exploit this possibility as a revolutionary weapon, often stressing in their work particularly those aspects of instinctual behaviour, acknowledgment of which was most repressed in society at large: sexuality in all its manifestations and man's addiction to violence and death. However, it should not be thought that the Surrealist ethos was in general negative and subversive. On the contrary, fundamental to Surrealism was the impulse to reveal and celebrate the potential magic of human existence.

In the Manifesto Breton gave a now celebrated dictionary definition of Surrealism: 'Surrealism, n.m. Pure psychic automatism by which it is proposed to express either verbally, or in writing or in any other way, the real function of thought. *Thought's dictation in the absence of all control exercised by reason and outside all aesthetic or moral preoccupation.*' Somehow the artist had to find a way of recording without interference, i.e. 'automatically', the pattern of thought, the flow of impulses from the subconscious mind, and the result would stand as art. In fact, Breton himself, in collaboration with the writer Philippe Soupault in 1920, had been a pioneer of the crucial technique of automatic writing, which he described in the Manifesto: 'Entirely preoccupied as I then still was with Freud and being conversant with his methods of examination which I had had some opportunity to practise myself during the war I resolved to obtain from myself what one tried to obtain from a patient, that is a monologue uttered as rapidly as possible on which no judgement is passed by the subject's critical faculties, which, therefore, is entirely without reticence and which is as nearly as possible spoken thought'. Breton is describing the psychoanalytic technique of free association, which was then to be recorded in writing. A text obtained in this way, titled *Soluble Fish*, was published by Breton as an accompaniment to the 1924 Manifesto. These are its opening lines: 'At that time of day the park spread its pale hands above the magic fountain. A castle without meaning travelled over the earth's surface. Near to God the castle's notebook lay open at a drawing of shadows, feathers and of irises, "At the Kiss of the Young Widow", it was the name of the inn caressed by the speed of the automobile and by plants suspended horizontally'. The value of automatic writing lies in the images which are brought together in bizarre and fantastic relationships thus creating a poetry of irrational juxtapositions which reflects very directly the patterns of unconscious thought. This poetic effect Breton referred to as 'convulsive beauty' and it is the basis of Surrealist aesthetics. 'Beauty will be CONVULSIVE or it will not be', he declared in his book *Nadja* (1928); in his later essay *Beauty Will Be Convulsive* he wrote, 'In my opinion there can be no beauty – convulsive beauty – except through the affirmation of the reciprocal relationship that joins an object in movement to the same object in repose. I am sorry not to be able to reproduce here the photograph of an express locomotive after having been abandoned for many years to the fever of the virgin forest.' This extraordinary image of a locomotive abandoned in the jungle, frozen in its tracks by vegetation, became famous as an example of convulsive beauty and in 1939 René Magritte painted one of his most memorable pictures, *Time Transfixed* (Plate 19), which clearly refers to it. An even more celebrated example of convulsive beauty was drawn from *Les Chants de Maldoror* ('The Songs of Maldoror') of Isidore Ducasse, self-styled Comte de Lautréamont (1846-70), one of the Surrealist's great heroes of the past: 'As beautiful as the chance

encounter of a sewing-machine and an umbrella on a dissecting table.' Comparisons like this, stated Breton in *Beauty Will Be Convulsive*, 'constitute the absolute manifesto of convulsive beauty'. In another book *L'Amour Fou* (1937) Breton also made it clear that convulsive beauty was for him, in some central sense, erotic: 'Right at the very bottom of the human crucible, in that paradoxical region where the function of two beings who have really chosen one another restores to all things the lost colours of the time of ancient suns, yet where the solitude also runs wild by one of those fantasies of nature which around the craters of Alaska decrees that snow remains buried beneath ashes, it is there that years ago I called for us to seek the new beauty, the beauty envisaged purely for passionate ends. I acknowledge without the least embarrassment my profound insensibility when faced by natural sights or works of art that do not immediately produce in me a state of physical disturbance characterised by the sensation of a wind brushing across my forehead and capable of causing me to really shiver. I have never been able to help relating this sensation to erotic pleasure and can discover between them only differences of degree. Although I have never been able to exhaust by analysis the constituent elements of this disturbance . . . what I already know of it is enough to assure me that it is governed by sexuality alone' (trans. by David Gascoyne, Faber, 1936). It is highly significant that Breton should equate erotic and aesthetic experience. For the Surrealists eroticism was undoubtedly the central fact of human existence and in the absence of God (they were of course devoted atheists) it was the only thing which gave existence a meaning: it need hardly be added that eroticism is therefore a distinguishing feature of Surrealist art.

As we have seen, the first application of Breton's 'pure psychic automatism' was to the production of literature. But what of the visual arts and especially the great classic medium of paint on canvas? Painting undoubtedly presented special difficulties for the Surrealists. For one thing it seemed to be hopelessly compromised as a traditional and bourgeois art form (Breton once referred to it as 'that lamentable expedient') and for another it seemed impossible to produce automatic painting in the same way as automatic writing. At the time of the Manifesto Breton does not seem to have been really concerned with painting. It is barely mentioned in the Manifesto as a whole, and is conspicuously absent from the famous definition. Not long after the Manifesto was published Pierre Naville wrote (in the group's magazine *Surrealist Revolution*), 'Everyone knows that there is no *Surrealist painting*.' This was in April 1925 and the first exhibition of Surrealist painters took place only six months later. Moreover when Breton wrote the Manifesto he almost certainly owned Max Ernst's painting *Of This Men Shall Know Nothing* (Plate 2), done in 1923. We now see this and one or two other works by Ernst of the early 1920s such as *Celebes* (Plate 1) of 1921 and *Oedipus Rex* of 1922, both of which belonged to Ernst's Surrealist friend Paul Éluard, as the first masterpieces of Surrealist painting. It is possible that Breton and the literary Surrealists were so obsessed with the idea of automatism that they failed to recognize the deliberately wrought paintings of Ernst as Surrealist. But Ernst had in fact succeeded in producing paintings which were a visual equivalent of the convulsive poetry of automatic writing: bizarre but precise images in strange juxtapositions which, like automatic writing, reflected more directly than ever before the patterns of unconscious thought. How had Ernst achieved this great breakthough? There were, it seems, two major steps. First, in 1919, Ernst discovered the work of the Italian 'metaphysical' painter Giorgio de Chirico. From about 1911 to 1918 de Chirico produced paintings such as *The Philosopher's Conquest* (1914; Fig. 1) which were in almost every way the models for the Surrealist work of Ernst

and those Surrealist painters such as Magritte, Delvaux and Dali who came after him. Indeed de Chirico's paintings of that time may be declared to be, in retrospect, Surrealist. The only difference, but an important one, between de Chirico and later Surrealists like Ernst, is that de Chirico's approach to painting the unconscious was largely intuitive while an artist like Ernst proceeded in full knowledge of the theories of Freud. A crucial characteristic of de Chirico's painting is that its composition, like that of automatic writing, is based on free association of images without regard for logic or the appearances of the normal external world. The objects are, so to speak, assembled in the picture. Max Ernst then saw that instead of laboriously painting each element, artichoke, cannon or whatever, he could make use of ready-made images from magazines, books and other printed sources such as trade catalogues. One of the advantages of this procedure was that the images could be arranged and re-arranged with complete freedom until the final composition was fixed. Thus about 1920 Ernst invented Surrealist collage, a step whose significance was later recognized by Breton when he wrote in *Genèse et Perspective Artistiques du Surréalisme* (1941) ' . . . we can easily see now that Surrealism was already in full force in the work of Max Ernst. Indeed Surrealism at once found itself in his 1920 collages.' Collage, stated Ernst himself, 'is the systematic exploitation of the fortuitous or engineered encounter of two or more intrinsically incompatible realities on a surface which is manifestly inappropriate for the purpose and the spark of poetry which leaps across the gap as these two realities are brought together.' (Cited by Uwe M. Schneede in *The Essential Max Ernst*, London, 1972.) It may well be supposed that when Ernst wrote this he had in mind Lautréamont's 'encounter' of the sewing-machine and umbrella on a dissecting table. Ernst has described how he discovered the possibilities of collage one day in 1919 as he was leafing through a trade catalogue: 'There I found,' he wrote, 'brought together, illustrations so alien to each other that the absurdity of the collection provoked in me a sudden intensification of my visual faculties and brought into being a hallucinating succession of contradictory images – double, triple and multiple – superimposing themselves one on another . . . All that was needed then was to add to these pages of the catalogue some paint or drawing in order to transform that which before had been no more than banal advertisements into dramas relevant to my most secret wishes.' (From *Cahiers d'Art*, 1937, 33.) This is a very vivid account of the way in which juxtapositions of given images can stimulate the unconscious and reveal the patterns of unconscious thought. Among the most haunting of Ernst's early collages is *Here Everything is Still Floating* of 1920 (Fig. 2), with its strange reversal of normality and the brilliant stroke of imagination by which Ernst has converted an anatomical engraving of a flea into a boat. It was the experience of collage which finally, in about 1921, enabled Ernst to return to the great medium of painting and with complete assurance create that series of masterpieces which marks the first flowering of Surrealist painting. Among the earliest of these *Celebes* (1921; Plate 1) is outstanding and two of its great successors were *Of This Men Shall Know Nothing* (Plate 2) and *Pietà or Revolution by Night* (Fig. 12), both of 1923. Detailed accounts of these works can be found in their individual captions, but they do reveal certain basic principles of Surrealist painting, its inspiration, technique and interpretation which may here be discussed in general terms.

It appears that Ernst's sources of inspiration included, as well as the pyscho-analytic technique of free association (fundamental, as we have seen, to Surrealist methodology in the form of automatic writing and collage) that other great pyschoanalytic tool, the analysis of dreams, a procedure which Freud declared 'the royal road to the unconscious'. Ernst in particular was well aware of the importance

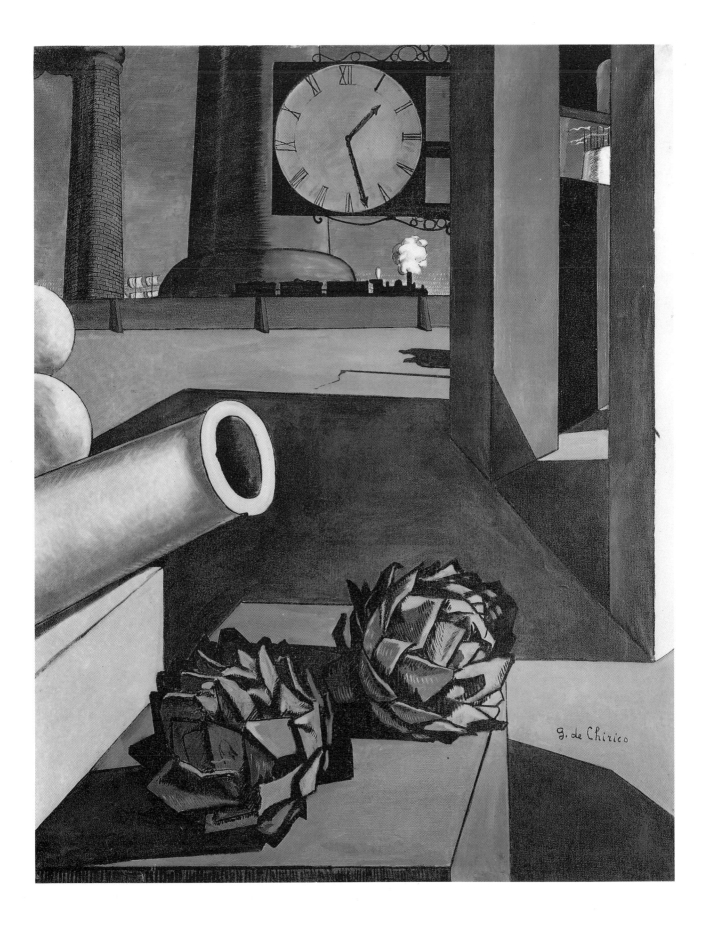

G. de Chirico

Fig. 2
MAX ERNST
Here Everything is Still Floating
Pasted photo-engravings
and pencil, 10.5 x 12.4 cm.
1920. Collection, The
Museum of Modern Art,
New York. Purchase

Freud attached to dreams as a revelation of the unconscious. We know from his autobiography that when he went to the University of Bonn in 1909 to study philosophy he planned eventually to specialize in psychiatry, and during this period he is said to have read two texts by Freud which are of central relevance to Surrealism, *The Interpretation of Dreams* and *Wit and its Relation to the Unconscious*.

The importance of dreams, trances and hallucinations and related states and phenomena to the Surrealists right from the start is illustrated by the well-known and crucial episode in the development of the Surrealist group which their first historian Maurice Nadeau named 'The Season of Sleeps' (*L'Époque des Sommeils*). Briefly, the excitement generated in the group around Breton by the results of the first automatic writing led them to seek more effective methods of stimulating the unconscious flow and in 1922-3 they began to experiment with hypnosis. It was then, as one of them, Louis Aragon, later recalled,that an epidemic of trances broke out among the Surrealists . . . There were some seven or eight who now lived only for those moments of oblivion when, with the lights out, they spoke without consciousness, like drowned men in the open air . . . ' (Louis Aragon, *Une Vague de Rêves*, 1924). Aragon was forcibly struck by 'the inspired character of the spoken dreams that paraded past me' at these communal day-dreaming sessions. Nocturnal dreams were also recorded. The actual visual quality of the early paintings of Ernst is strongly dreamlike and indeed this kind of Surrealist painting is commonly referred to as *oneiric* (i.e. dreamlike).

Dreams often contain long-forgotten memories and such memories too can be stimulated during our waking hours. Memories from both sources often play an important part in Surrealist painting. A further aspect of dreams important to the Surrealists was Freud's theory that unconscious thought often expressed itself in symbols where the subject of the thought was 'forbidden', e.g. sexual. Freud gave long lists of sexual symbols in *The Interpretation of Dreams*, examples of which can be found in many Surrealist paintings. Again according to his autobiography Ernst was strongly affected when he first discovered art by the insane – such art is usually the untrammelled expression of unconscious impulses and all the Surrealists took a deep interest in it as well as in other art produced spontaneously by people outside the conventional art-community or from other societies – so called naïve and primitive art.

Not all the painters drawn into the Surrealist group adopted the oneiric manner derived from de Chirico. Indeed almost from the moment of publication of the Manifesto in 1924 it became apparent that another quite distinct approach to the making of paintings from the unconscious had come into existence. The chief exponents of this alternative approach were Joan Miró, André Masson and last but not least (though perhaps surprisingly) Max Ernst himself, who radically changed his style in 1924-5.

Miró and Masson met in Paris in the winter of 1922-3 and together quickly found their way into the circle around Breton at the very time Breton was preparing the first Manifesto. 'The tumultuous entry of Miró', Breton later wrote, 'marked an important stage in the development of Surrealist art', and he also once remarked, 'Miró may pass for the most Surrealist of us all'. Breton's enthusiasm is easily explained by the fact that Miró's way of painting appeared much closer to automatic writing and therefore closer to Breton's original definition of Surrealism as 'pure psychic automatism' than the oneiric style. Indeed, the approach to painting established by Miró and Masson about 1924-5 can conveniently be referred to as *automatic*. The essential difference between automatic Surrealist painting and oneiric is one of spontaneity (or automatism) in the actual execution. This led to an increasing degree of abstraction so that the precise figurative

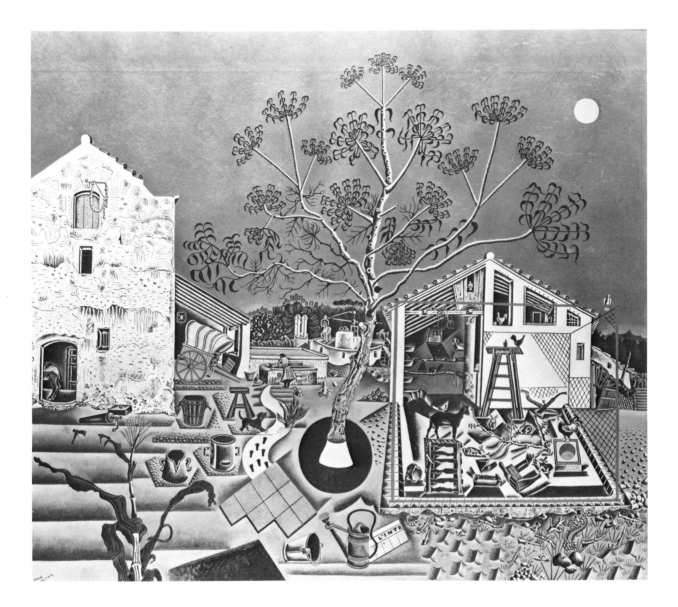

imagery of oneiric Surrealism gives way to a system of signs and symbols. This process can be clearly seen in the work of Miró from 1922 to 1924. In *The Farm* of 1921-2 (Fig. 3) everything is still painted with great precision although the teeming imagery already reflects Miró's extraordinary ability to express a universal vision of the life of this world and the cosmos. By 1924, when he painted *Maternity* (Plate 4), Miró's Surrealist manner was fully evolved. The imagery now consists of biological signs representing fundamental life-processes in a cosmic setting. Such imagery is usually referred to as *biomorphic* and it became an important and fruitful element in much Surrealist painting and sculpture. Miró described his working process to the American art historian James J. Sweeney in 1948: 'Rather than setting out to paint something, I begin painting. As I paint the picture begins to assert itself under my brush. The form becomes a sign for a woman or a bird as I work . . . the first stage is free, unconscious.' Miró is said to have started one painting around a stain made by blackberry jam accidently spilled on the canvas. The extraordinary spontaneity of Miró's work of this time may be partly explained by another statement recorded by Sweeney: 'In 1925 I was drawing almost entirely from hallucinations. At the time I was living on a few dried figs a day. Hunger was a great source of these hallucinations. I would sit for long periods looking at the bare walls of my studio trying to capture these shapes on paper or canvas.'

Fig. 3
JOAN MIRÓ
The Farm
Oil on canvas,
122.5 x 140.3 cm. 1921-2.
New York, Collection of
Mrs Ernest Hemingway

André Masson's first 'automatic' works were extraordinary freely doodled drawings out of which strange, often erotic or violent images emerged. In 1927, however, he found his own method of automatic painting. This is his description of what happened: 'It was at the beginning of 1927, I was living by the sea and one day I wondered why I shouldn't use *sand* in an automatic way. I had noticed that my first automatic drawings were born from a method, I knew what I had to do: empty oneself, make oneself completely available without any premeditation. Ink and white paper, usually in very large sheets, enabled me to make a drawing in a few seconds. I did not think about what I was doing. Only afterwards did I see that there were signs that could be interpreted. But in oil painting an element of resistance, stemming from the canvas and the preparation of the colours, prevented any automatism. I had to find a way. That was Sand. I began by laying flat a piece of canvas on a stretcher covered with raw canvas. On it I threw pools of glue that I manipulated. Then I scattered sand, then shook the picture to produce splashes and pools, sometimes I scraped it with a knife. I obtained something which had no meaning but which could stimulate meaning. And all this done at express speed. I took different grades of sand . . . building up successive layers with more glue, in the end it became a sort of wall, a very uneven wall, and then at particular moments the layers would suggest froms although almost always irrational ones. With a little thinned paint I added a few lines, but as rapidly as possible and then, already calming down a bit, a few touches of colour. Nearly always the sky was indicated at the top with a little patch of blue and at the bottom there would always be a pool of blood, I have no idea why.' (Quoted by Clébert in *Mythologie d'André Masson*, Geneva, 1971. Present writer's translation.) Masson eventually produced a group of about twenty of these paintings, among them the great *Battle of Fishes* (Plate 9) now in the Museum of Modern Art in New York.

There seems little doubt that Max Ernst's contacts with Miró and Masson led him away from his early style towards automatism and he too developed his own personal method which he called *frottage* and which was based on the simple technique of making rubbings from textured objects whose configurations stimulated the process of free association. Ernst was partly inspired, it seems, by the famous passage in Leonardo da Vinci's *Treatise on Painting* where Leonardo, speaking of 'spots on walls, certain aspects of ashes on the hearth, of clouds, of streams', says 'if you consider them carefully you will discover most admirable inventions which the painter's genius can turn to good account in composing battles (both of animals and men) landscapes or monsters, demons and other fantastic things that will do credit to you.' In his autobiographical book *Beyond Painting* (1936) Ernst tells how 'On 10 August 1925 an overpowering visual obsession led me to discover the means of putting Leonardo's lesson into practice. Finding myself in an inn by the sea [Ernst was staying at Pornic in Brittany] I was struck by the obsession exerted upon my excited gaze by the floor – its grain accented by a thousand scrubbings. I then decided to explore the symbolism of this obsession, and to assist my contemplative and hallucinatory faculties I took a series of drawings from the floorboards by covering them at random with sheets of paper which I rubbed with soft pencil. When I gazed attentively at these drawings I was surprised at the sudden intensification of my visionary faculties and at the hallucinatory succession of contradictory images being superimposed on each other with the persistence and rapidity of erotic memories.' The best known group of frottage drawings are those published in book form in 1926 under the title *Histoire Naturelle*. One of these is *The Fugitive* (Fig. 4), which is typical of the strange dream-world of forests, birds, beasts and fishes evoked in these drawings. Like the automatic works of Miró and Masson these

images seem to come from a deep level of the subconscious where we carry our awareness of life's distant origins in primeval forests and seas presided over by the sun, the moon and the stars. In the case of Ernst the forest and the sun became particularly important images in the frottage paintings which he soon began to make (Plate 10). He appears to have used a variety of techniques in adapting the frottage concept to oil painting but basically paintings like *Forest and Dove* (Plate 12) seem to have been done by applying two or more layers of different coloured ground, then placing the canvas over the textured surface or object and scraping through the top layer. Considerable work with the brush may then be done on this foundation.

One other artist must be mentioned in connection with the development of 'automatic' forms of Surrealist painting, Pablo Picasso. Picasso was never, it must be stressed, formally a member of the Surrealist group. However, he was represented in the first group exhibition of Surrealist painting at the Galerie Pierre in Paris in 1925, his work was much reproduced in the Surrealist periodicals, and Breton's own writings on Picasso are in a tone of complete adulation. What may be designated Picasso's Surrealist period began quite abruptly in 1925 with one of those clear shifts in style which had already occurred at least twice before in his career. The work which more than any other marks this shift is *The Three Dancers* of 1925 (Plate 13) which, almost before the paint was dry, was reproduced by Breton, together with four other works by Picasso, in the 15 July 1925 issue of the magazine *La Révolution Surréaliste*. Over the next decade Picasso became a dominant and influential contributor to Surrealism, in particular developing an increasingly original and fantastic treatment of the human figure typified by his famous sequence of drawings *Une Anatomie* (Fig. 5), published in the Surrealist periodical *Minotaure* in 1933.

Finally, the question of the interpretation of Surrealist painting must be briefly considered. It may be suggested that in general Surrealist art can be read on two main levels, the personal and the

Fig. 4
MAX ERNST
The Fugitive
Black lead pencil,
26.5 x 42.8 cm. 1925.
Stockholm, Moderna
Museet

universal. Obviously much of the content of the unconscious is personal and interpretation of it must be largely dependent on our knowledge of the artist. In the case of Ernst, for example, or Salvador Dali, autobiography supplies a good number of clues to the personal element in their painting. On the other hand little is known of Magritte or Miró, and their paintings remain the most enigmatic of all Surrealist works. (Furthermore, in the case of Miró and the other 'automatic' Surrealists the imagery is itself more difficult to read.) However at another, perhaps deeper, level the unconscious contains material common to all human existence. This was very well summarized by Dali when he said, 'The Subconscious has a symbolic language that is truly a universal language for it does not depend on education or culture or intelligence but speaks with the vocabulary of the great vital constants, sexual instinct, awareness of death, sense of the mystery of space – these vital constants are universally echoed in every human being.'

The automatism of Miró, Masson, Ernst and Picasso dominated Surrealist art in the first two years of the movement. However, in 1927 the de Chirico-based oneiric tradition re-surfaced in the work of the Belgian painter René Magritte, who moved to Paris in that year. Magritte had already played an important part in the foundation of a Surrealist group in Brussels together with his friend E. L. T. Mesens (see Fig. 22). He first came across the work of de Chirico in about 1922 and subsequently devoted the rest of his long career to a consistent exploration of the possibilites of this art, extending it in new directions and creating an *oeuvre* of great complexity and profundity. His point of departure was that fundamental revelatory mechanism of de Chirico and early Ernst: to quote Ernst himself, 'the spark of poetry which leaps across the gap when two realities are brought together'. The range of Magritte's complex art is so great that it is almost impossible to generalize about it. However, it may be said that one central characteristic is that it deals with the response of the unconscious mind to the world of everyday objects. These objects Magritte almost always paints in an absolutely dead-pan straightforward way with none of the fantastic variations characteristic of, for example, Ernst (for example in *Celebes*), although, disconcertingly, one object may suddenly turn into another.

The other central fact of Magritte's work is that it has the character of a philosophical investigation into the nature of our relationship with objects, into the relationship between the painted object and reality, and finally into the nature of reality itself. It is this undoubted intellectual profundity which helps to make Magritte one of the individual giants of modern art, his significance extending far beyond the specific context of Surrealism.

The final seal was set on the dominance of oneiric Surrealism in the late 1920s with the arrival in Paris in 1929 of the Spanish painter Salvador Dali who, it may be said, developed this kind of Surrealist painting to its most extreme form. The basis of Dali's art was an entirely personal inspirational system which he called the 'Paranoiac-Critical' method, allied to a high precision, ultra-illusionist technique. The Paranoiac-Critical method is really an extension of Dali's own fevered personality, the nature of which he himself admirably summed up when he said, at the opening of an exhibition of his work in 1934, 'The only difference between me and a madman is that I am not mad.' It is precisely Dali's ability to think like a madman without actually being mad that has, it seems, enabled him to generate his unique imagery. The form of madness in question, paranoia, is a condition in which the sufferer erects a complete delusional system which he has constantly to impose on external reality by a process of, in Dali's phrase, 'systematic associations'. In other words paranoia involves the transformation of reality to correspond to unconscious

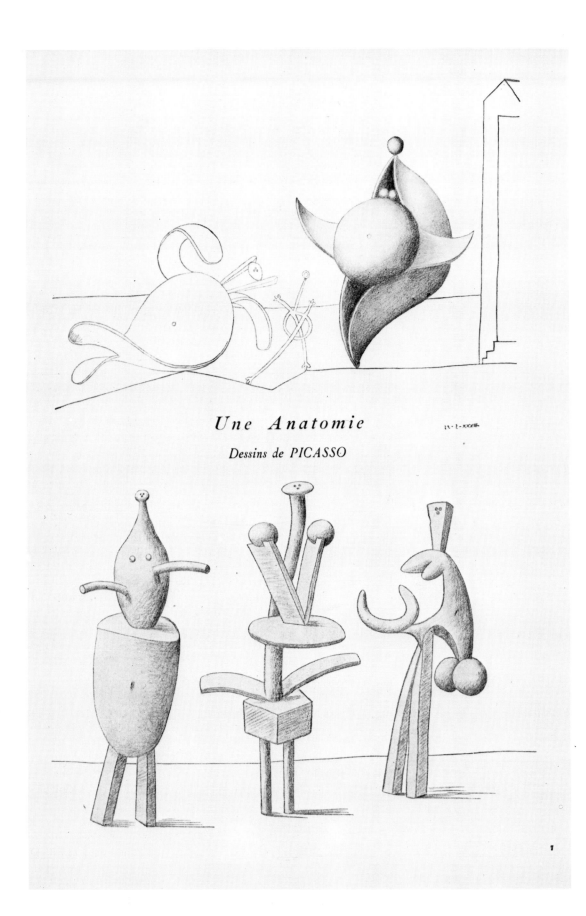

Une Anatomie

Dessins de PICASSO

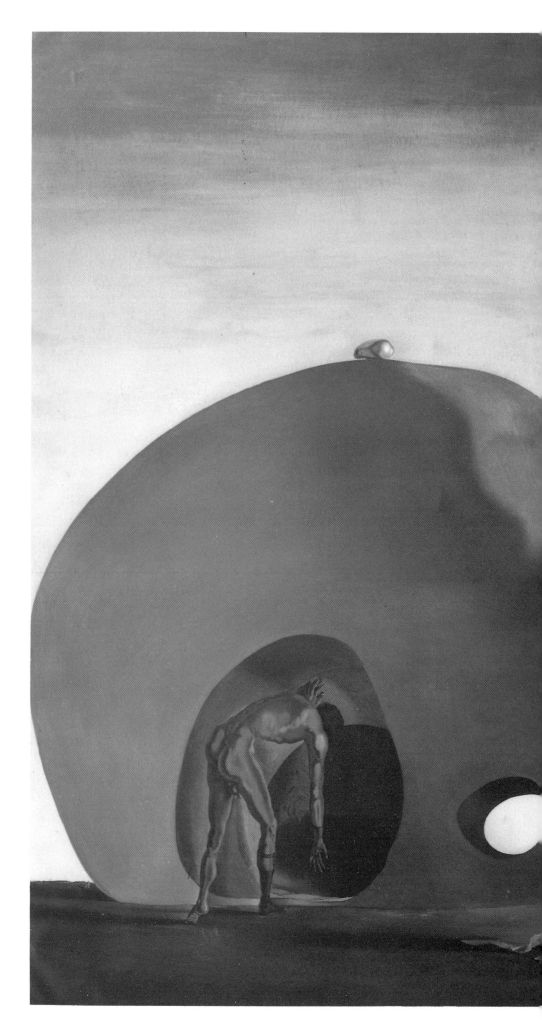

Fig. 6
SALVADOR DALI
The Birth of Liquid
Desires
Oil on canvas,
95 x 112 cm. 1932. New
York, Solomon R.
Guggenheim Foundation
(Peggy Guggenheim
Collection)

fantasy. As Dali later wrote, 'It was in 1929 that Salvador Dali brought his attention to bear upon the internal mechanisms of paranoiac phenomena and envisaged the possibility of an experimental method based on the sudden power of the systematic associations proper to paranoia; this method afterwards became the delirio-critical synthesis which bears the name of paranoiac-critical activity.' Dali's technique has also been well described by himself as 'Instantaneous and hand-done colour photography of the superfine, extravagant, extra-plastic, extra-pictorial, unexplored, super-pictorial, super-plastic, deceptive, hyper-normal and sickly images of concrete irrationality', and his aim in adopting such a technique was to render the world of the unconscious with as much conviction as possible: 'My whole aim in the pictorial domain is to materialize the images of concrete irrationality with the most imperialist fury of precision.' *The Birth of Liquid Desires* (1932; Fig. 6) is one of the early masterpieces resulting from the application of Dali's methods. Like most of his earliest Surrealist works it deals with a wide range of sexual preoccupations and fetishes.

Dali made another contribution to Surrealist art. In 1931, in the third issue of the Surrealist magazine *Le Surréalisme au Service de la Révolution*, he published an article entitled 'Surrealist Objects' and thereby gave vital stimulus to object-making, a fascinating and important area of Surrealist art. The Surrealist object is essentially a three-dimensional collage using existing real elements and was defined by Dali as 'absolutely useless from the practical and rational point of view, created wholly for the purpose of materializing in a fetishistic way, with the maximum of tangible reality, ideas and fantasies having a delirious character.' Among the best-known Surrealist objects are Meret Oppenheim's *Object* ('Fur Breakfast', 1936; Fig. 7), Dali's own *Lobster Telephone* (1936; Fig. 26) and the German Surrealist Hans Bellmer's *Doll* (1936; Fig. 29). Magritte also produced a number of objects, one of which is *The Future of Statues* (1937; Fig. 23), and after Dali's article object-making became widespread among all Surrealists.

In addition to Surrealist objects there exists a body of true Surrealist sculpture – that is, made not from existing elements but using the traditional sculptural techniques of carving, modelling and casting. The great Surrealist sculptor was undoubtedly Alberto Giacometti, who produced a body of work of remarkable originality during the relatively brief period of his affiliation to the Surrealist group in Paris from 1929 to 1935. In fact Dali reproduced a group of Giacometti's drawings for sculptures titled *Objets Mobiles et Muets* (Fig.9) in his article on the Surrealist object mentioned above. Another major work of this period by Giacometti is *L'Heure des Traces* (see Fig. 16). This and his other Surrealist sculptures can perhaps be seen as three-dimensional equivalents to Miró's biomorphic paintings: abstract yet expressive of fundamental processes of life – in Giacometti's case sexuality sometimes combined with a disturbing aggression as in, for example, the object depicted at the lower right of *Objets Mobiles et Muets*. Max Ernst spent the summer of 1934 with Giacometti at a studio he had rented near Stampa. Ernst began to make sculpture, first using found objects but, back in Paris, he began modelling an imposing series of sculptures of strange totemic figures.

Jean Arp must also be mentioned in the context of Surrealist sculpture although his work has a formal purity which may be thought antithetical to Surrealism and he did in fact exhibit with the abstract group Abstraction-Création. However, Arp had of course been a founder member of the Dada group in Zurich and subsequently a member of the Surrealist group and was much admired by Breton. Furthermore he was the undoubted inventor of biomorphic imagery, which he developed in his characteristic reliefs from about

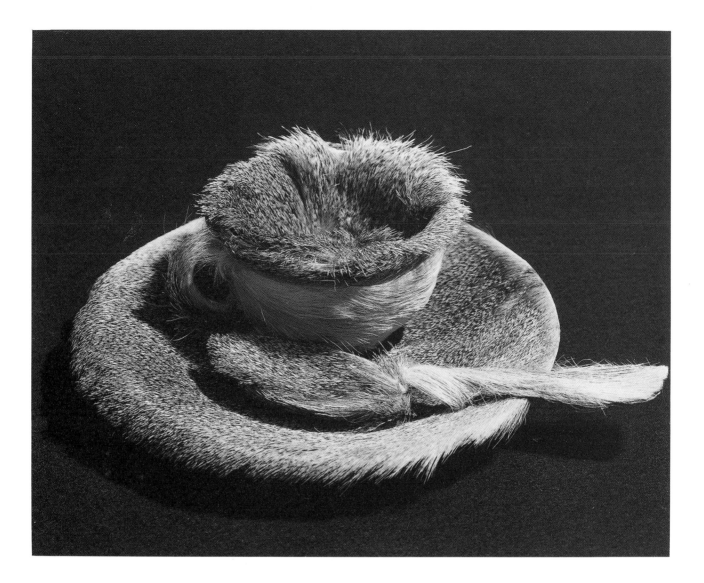

Fig. 7
MERET OPPENHEIM
Object
Fur-covered cup, saucer
and spoon, overall height
7.5 cm. 1936. Collection,
The Museum of Modern
Art, New York

1915 onwards and in his fully in-the-round sculptures from 1930 (Fig. 8). However his biomorphism tends to refer only to vegetable forms and processes and it was left to a painter like Miró and a sculptor like Henry Moore to develop a much more widely and powerfully expressive biomorphic language (Fig. 10). Henry Moore was one of the organizing committee of the International Surrealist Exhibition held in London in 1936, which marked the official launching of Surrealism in England. Other prominent English members of the committee were Roland Penrose, Herbert Read and Paul Nash. They were advised by E. L. T. Mesens, who two years later moved to London and became a key figure in the English Surrealist movement. He took over the London Gallery, organizing exhibitions for Ernst, Tanguy, Magritte and de Chirico among others. He also founded and edited the *London Bulletin*, which quickly developed into a review of the whole avant-garde, not just of Surrealism. Finally, one outstanding English patron of Surrealist art should be mentioned: this was Edward James, who virtually supported Dali in the mid-1930s and was a major patron of Magritte. In addition to a number of Dali's greatest works he acquired most of the major Surrealist paintings of Nash, including *Harbour and Room* (Fig.11).

England it may be suggested was particularly ripe for Surrealism by 1936. As Herbert Read, the theorist and philosopher of the group (and of course of modern art in general) perceived, there is an English tradition of poetic imagination and fantasy running back in literature through Lewis Carroll, Coleridge and the gothic novelists to Young (*Night Thoughts*) and Swift. In art the line runs back through

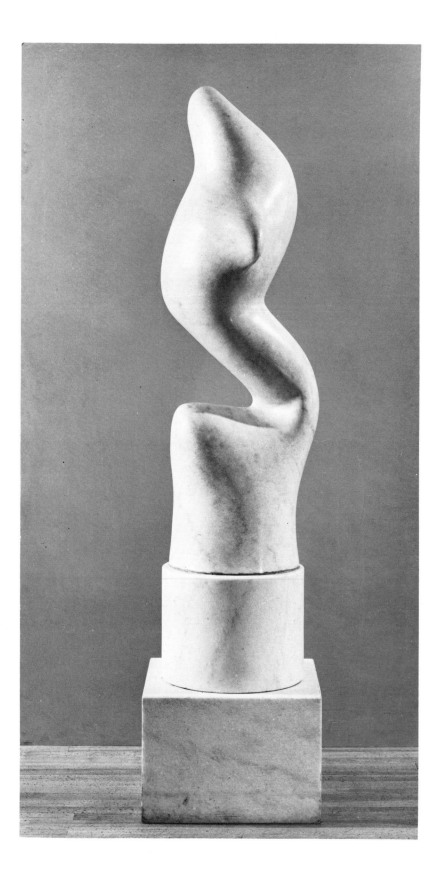

Fig. 8
JEAN ARP
'S'Élevant'
Marble, 177 cm. 1962.
Edinburgh, Scottish
National Gallery of
Modern Art

Fig. 9 (top)
ALBERTO GIACOM-
ETTI
'Objets Mobiles et
Muets'
From *Le Surréalisme au
Service de la Révolution*,
No. 3, December 1931

Fig. 10
HENRY MOORE
Four-piece
Composition
(Reclining Figure)
Cumberland alabaster,
18 x 41 x 17 cm. 1934.
London, Tate Gallery

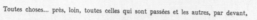

OBJETS MOBILES ET MUETS

Toutes choses... près, loin, toutes celles qui sont passées et les autres, par devant,

qui bougent et mes amies — elles changent (on passe tout près, elles sont loin), d'autres approchent, montent, descendent, des canards sur l'eau, là et là, dans l'espace, montent,

descendent — je dors ici, les fleurs de la tapisserie, l'eau du robinet mal fermé, les dessins du rideau, mon pantalon sur une chaise, on parle dans une chambre plus loin ; deux ou

18

trois personnes, de quelle gare? Les locomotives qui sifflent, il n'y a pas de gare par ici,

on jetait des pelures d'orange du haut de la terrasse, dans la rue très étroite et profonde — la nuit, les mulets braillaient désespérément, vers le matin, on les abattait — demain je sors —

elle approche sa tête de mon oreille — sa jambe, la grande — ils parlent, ils bougent, là et là, mais tout est passé.

Alberto GIACOMETTI.

19

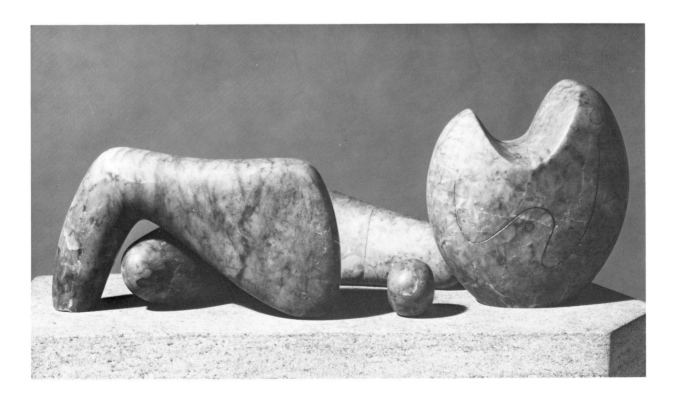

23

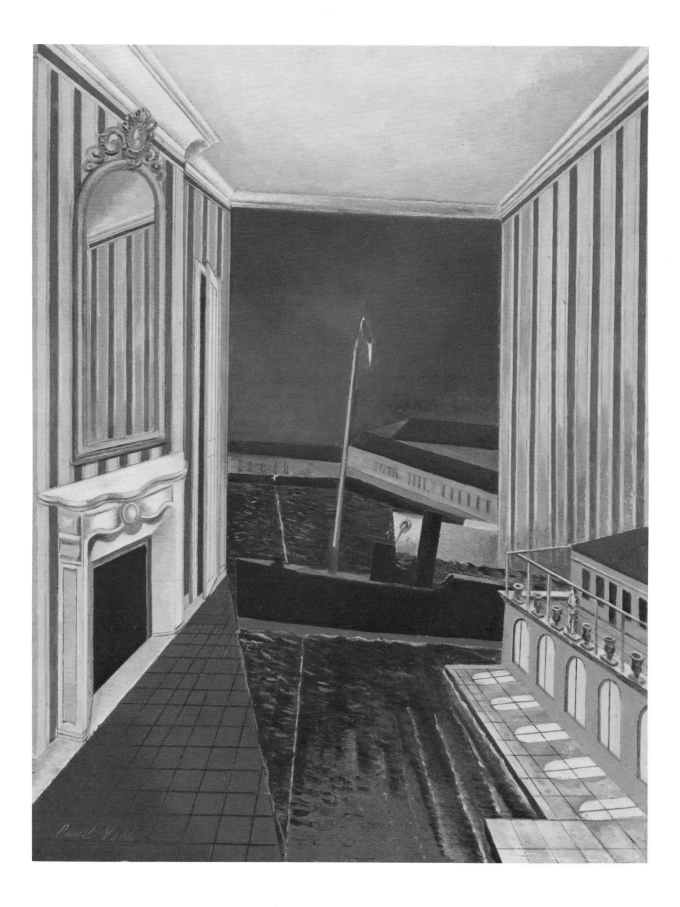

Burne-Jones, Rossetti, early Millais, Richard Dadd, John Martin and Fuseli to Blake. Certainly a large number of English artists found themselves to be Surrealist at the time of the 1936 exhibition, and significant contributions have been made in particular by Edward Burra (Plate 45), John Banting (Fig. 35), Eileen Agar (Fig. 31), Julian Trevelyan, Humphrey Jennings, F. E. McWilliam (Fig. 36) and Conroy Maddox (Fig. 34). However, the English movement was never as coherent or as doctrinaire as the Paris group and after the last issue of *London Bulletin* was published in 1940 organized Surrealism more or less ceased to exist in England.

The great period of Surrealism came to an end with the outbreak of the Second World War. Analysis of its pervasive and persistent influence on many aspects of western culture since then is beyond the scope of this essay, but a word may be added on Surrealism's influence on what is seen as the mainstream of development of painting. At the outbreak of war, and especially after the occupation of France, many European artists fled to America. Among them were the Surrealists Max Ernst, André Breton, André Masson and Roberto Mattax, one of the last major talents to join the Surrealists before the war. Their presence in New York proved catalytic for a whole generation of talented and ambitious American painters who, although mostly nearing middle age, had yet to find a truly personal voice. During the war years these artists, prominent among them Jackson Pollock and Mark Rothko, took up the Surrealist concept of automatism as a means of painting out of the unconscious. Through the immediate post-war years these two great painters evolved in different directions but between them, and out of Surrealism, they launched the next great phase of western painting.

Fig. 11
PAUL NASH
Harbour and Room
Oil on canvas,
91.4 x 71 cm. 1932-6.
London, Tate Gallery

Select Bibliography

Sarane Alexandrian, *Surrealist Art* (World of Art series), London, 1970

Anna Balakian, *Surrealism: The Road to the Absolute*, London, 1972

André Breton, *Surrealism and Painting* (trans. Simon Watson Taylor), London, 1978

Richard Calvocoressi, *Magritte* (Phaidon Colour Library series), London, 1984

Marcel Jean, *The History of Surrealist Painting* (trans. Simon Watson Taylor), London, 1960

Maurice Nadeau, *The History of Surrealism* (trans. Richard Howard), London, 1968

Gaetan Picon, *Surrealism 1919-1939*, Geneva, 1977

Jose Pierre, *A Dictionary of Surrealism* (trans. W. J. Strachan), London, 1974

Herbert Read (ed.), *Surrealism*, London, 1936

W. S. Rubin, *Dada and Surrealist Art*, London, 1969

CATALOGUES

Dada and Surrealism Reviewed, catalogue of the Arts Council exhibition at the Hayward Gallery, London, 11 January - 27 March 1978

Max Ernst: A Retrospective, catalogue of an exhibition at the Tate Gallery, London, 13 February - 21 April 1991

List of Illustrations

Colour Plates

1. Max Ernst: Celebes
Oil on canvas. 1921. London, Tate Gallery

2. Max Ernst: Of This Men Shall Know Nothing
Oil on canvas. 1923. London, Tate Gallery

3. Max Ernst: The Equivocal Woman (The Teetering Woman)
Oil on canvas. 1923. Düsseldorf, Nordrhein-Westfalen Collection

4. Joan Miró: Maternity
Oil on canvas. 1924. Private Collection

5. Joan Miró: The Birth of the World
Oil on canvas. 1925. New York, The Museum of Modern Art

6. Joan Miró: Stars in Snails' Sexes
Oil on canvas. 1925. Düsseldorf, Nordrhein-Westfalen Collection

7. Joan Miró: Photo: This is the Colour of My Dreams
Oil on canvas. 1925. Private Collection

8. Joan Miró: Painting
Oil on canvas. 1927. London, Tate Gallery

9. André Masson: Battle of Fishes
Mixed media. 1926. New York, The Museum of Modern Art

10. Max Ernst: The Whole City
Oil on canvas. 1935. Zurich, Kunsthaus

11. Max Ernst: Europe after the Rain
Oil on canvas. 1940-2. Hartford, Conn., Wadsworth Atheneum

12. Max Ernst: Forest and Dove
Oil on canvas. 1927. London, Tate Gallery

13. Pablo Picasso: The Three Dancers
Oil on canvas. 1925. London, Tate Gallery

14. Pablo Picasso: Nude Woman in a Red Armchair
Oil on canvas. 1932. London, Tate Gallery

15. René Magritte: The Reckless Sleeper
Oil on canvas. 1927. London, Tate Gallery

16. René Magritte: Pleasure
Oil on canvas. 1926. Düsseldorf, Nordrhein-Westfalen Collection

17. René Magritte: The Menaced Assassin
Oil on canvas. 1926. New York, The Museum of Modern Art

18. René Magritte: The Red Model
Oil on canvas. 1934. Rotterdam, Boymans-Van Beuningen Museum

19. René Magritte: Time Transfixed
Oil on canvas. 1939. The Art Institute of Chicago

20. Paul Delvaux: The Call of the Night
Oil on canvas. 1937. Private Collection

21. Paul Delvaux: The Public Voice
Oil on canvas. 1948. Brussels, Musées Royaux

22. Paul Delvaux: The Night Train
Oil on canvas. 1947. Private Collection

23. Paul Delvaux: Sleeping Venus
Oil on canvas. 1944. London, Tate Gallery

24. Yves Tanguy: Mama, Papa is Wounded!
Oil on canvas. 1927. New York, The Museum of Modern Art

25. Yves Tanguy: Outside
Oil on canvas. 1929. Private Collection

26. Yves Tanguy: The Ribbon of Extremes
Oil on canvas. 1932. Private Collection

27. Salvador Dali: The Persistence of Memory
Oil on canvas. 1931. New York, The Museum of Modern Art

28. Salvador Dali: Sleep
Oil on canvas. 1937. Private Collection

29. Salvador Dali: Soft Construction with Boiled Beans: Premonition of Civil War
Oil on canvas. 1936. Philadelphia Museum of Art, The Louise and Walter Arensberg Collection

30. Salvador Dali: Autumn Cannibalism
Oil on canvas. 1936. London, Tate Gallery

31. Salvador Dali: The Metamorphosis of Narcissus
Oil on canvas. 1938. London, Tate Gallery

32. Pierre Roy: Danger on the Stairs
Oil on canvas. 1927-8. New York, The Museum of Modern Art

33. Pierre Roy: A Naturalist's Study
Oil on canvas. 1928. London, Tate Gallery

34. Max Ernst: The Robing of the Bride
Oil on canvas. 1940. Venice, The Peggy
Guggenheim Collection

35. Leonor Fini: Figures on a Terrace
Oil on canvas. 1938. Edward James Foundation

36. Dorothea Tanning: 'Eine Kleine
Nachtmusik'
Oil on canvas. 1946. Private Collection

37. Man Ray: Pisces
Oil on canvas. 1938. London, Tate Gallery

38. Hans Bellmer: Peg-top
Oil on canvas. c.1937-52. London, Tate Gallery

39. Balthus: Sleeping Girl
Oil on millboard. 1943. London, Tate Gallery

40. Balthus: Girl and Cat
Oil on panel. 1937. Private Collection

41. Paul Nash: Landscape from a Dream
Oil on canvas. 1936-8. London, Tate Gallery

42. Roland Penrose: Winged Domino (Portrait
of Valentine)
Oil on canvas. 1937. Private Collection

43. Conroy Maddox: Passage de l'Opéra
Oil on canvas. 1940. London, Tate Gallery

44. John Armstrong: Dreaming Head
Tempera on wood. 1938. London, Tate Gallery

45. Edward Burra: John Deth
Gouache. 1932. Private Collection

46. Roberto Matta: The Hanged Man
Oil on canvas. 1942. Basel, Galerie Beyeler

47. Roberto Matta: The Vertigo of Eros
Oil on canvas. 1944. New York, The Museum of
Modern Art

48. Roberto Matta: Black Virtue
Oil on canvas. 1943. London, Tate Gallery

Text Illustrations

1. Giorgio de Chirico: The Philosopher's
Conquest
Oil on canvas. 1914. The Art Institute of Chicago

2. Max Ernst: Here Everything is Still Floating
Pasted photo-engravings and pencil. 1920.
New York, The Museum of Modern Art

3. Joan Miró: The Farm
Oil on canvas. 1921-2. New York, Collection of
Mrs Ernest Hemingway

4. Max Ernst: The Fugitive
Black lead pencil. 1925. Stockholm, Moderna Museet

5. Pablo Picasso: 'Une Anatomie'
From 'Minotaure' I, 1933. British Library

6. Salvador Dali: The Birth of Liquid Desires
Oil on canvas. 1932. New York, Solomon R.
Guggenheim Foundation
(Peggy Guggenheim Collection)

7. Meret Oppenheim: Object
Fur-covered cup, saucer and spoon. 1936. New
York, The Museum of Modern Art

8. Jean Arp: 'S'Élevant'
Marble. 1962. Edinburgh, Scottish National
Gallery of Modern Art

9. Alberto Giacometti: 'Objets Mobiles et
Muets'
Illustration from 'Le Surréalisme au Service de la
Révolution', No. 3, December 1931

10. Henry Moore: Four-piece Composition
(Reclining Figure)
Cumberland alabaster. 1934.
London, Tate Gallery

11. Paul Nash: Harbour and Room
Oil on canvas. 1932-6. London, Tate Gallery

Comparative Figures

12. Max Ernst: Pietà or Revolution by Night
Oil on canvas. 1923. London, Tate Gallery

13. Max Ernst: Inscription on reverse of 'Of This Men Shall Know Nothing'

14. Max Ernst: At the First Clear Word
Oil on canvas. 1923. Düsseldorf, Nordrhein-Westfalen Collection

15. Max Ernst: Two Children are Threatened by a Nightingale
Oil on wood with wood construction. 1924. New York, The Museum of Modern Art

16. Alberto Giacometti: 'L'Heure des Traces' (Hour of the Traces)
Painted plaster and metal rods. 1930. London, Tate Gallery

17. Joan Miró: Object
Assemblage. 1936. New York, The Museum of Modern Art

18. Max Ernst: Showing the Head of her Father to a Young Girl
Oil on canvas. 1926. Private Collection

19. Pablo Picasso: Figures by the Sea
Oil on canvas. 1931. Private Collection

20. René Magritte: The Treason of Images
Oil on canvas. 1929. Los Angeles County Museum of Art

21. René Magritte: The Use of Words
Oil on canvas. 1928. Cologne, Galerie Rudolf Zwirner

22. E. L. T. Mesens: 'Mouvement Immobile II'
Collage and watercolour on cardboard. 1960. London, Tate Gallery

23. René Magritte: The Future of Statues
Painted plaster bust. c.1937. London, Tate Gallery

24. Giorgio de Chirico: The Enigma of Time
Oil on canvas. 1911. Private Collection

25. René Magritte: Man with a Newspaper
Oil on canvas. 1928. London, Tate Gallery

26. Salvador Dali: Lobster Telephone
Mixed media. 1936. London, Tate Gallery

27. Salvador Dali: Mountain Lake
Oil on canvas. 1938. London, Tate Gallery

28. Max Ernst: Yachting
Collaged engraving from 'La Femme 100 Têtes.' 1929. Private Collection. Photography by Jacqueline Hyde, Paris

29. Hans Bellmer: The Doll
Photograph tinted with coloured ink. c.1937-8. London, Tate Gallery

30. Paul Nash: Swanage
Collage. c.1936. London, Tate Gallery

31. Eileen Agar: Fish Circus
Mixed media. 1936. Private Collection

32. Roland Penrose: Captain Cook's Last Voyage
Mixed media. 1936. Private Collection

33. Roland Penrose: Magnetic Moths
Collage. 1938. London, Tate Gallery

34. Conroy Maddox: The Strange Country
Collage. 1940. London, Tate Gallery

35. John Banting: Conversation Piece
Tempera on paper. 1935. London, Tate Gallery

36. F. E. McWilliam: Eye, Nose and Cheek
Stone sculpture. 1939. London, Tate Gallery

37. Edward Burra: Keep Your Head
Collage. 1930. London, Tate Gallery

38. Arshile Gorky: The Liver is the Cock's Comb
Oil on canvas. 1944. Buffalo, Albright-Knox Art Gallery

The Plates

MAX ERNST (1891-1976)

Celebes

Oil on canvas, 126 x 108 cm. 1921. London, Tate Gallery

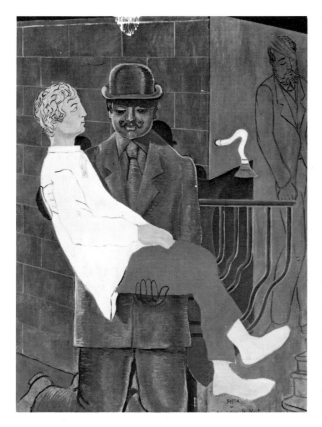

Fig. 12
MAX ERNST
Pietà or Revolution
by Night

Oil on canvas,
116 x 89 cm. 1923.
London, Tate Gallery

The first substantial masterpiece of Ernst's early Surrealist phase. What is known of it reveals much of the inspirational processes behind such painting. The central, elephant-like monster comes from a photograph of a Sudanese corn-storage bin found in an anthropological journal. The title, Ernst told his friend Roland Penrose, comes from a German school-boy rhyme about elephants that Ernst remembered from his youth – a memory perhaps stimulated by the elephant-like appearance of the corn-bin image: 'The elephant from Celebes/has sticky yellow bottom-grease/The elephant from Sumatra, etc.' (Celebes is a large Indonesian island whose outline roughly resembles that of an elephant.) The mechanistic character of the monster taken with its setting, apparently an airfield, and the smoke-trail in the sky suggesting a shot down aircraft, raises the possibility that another source for this painting might be a nightmare memory of Ernst's traumatic experiences in the German army during the 1914-18 War.

Pietà (Fig. 12) is another of the great masterpieces of early Surrealist painting. Its mysterious imagery seems to deal primarily with Freud's concept of the Oedipus complex – the son's rivalry with the father for the mother's affection and his fear of castration by the father. The father-figure kneels, holding the son in a pose that is reminiscent both of a scene of sacrifice and of a traditional Pietà. The shower-head is a phallic symbol and has beneath it a sharp, blade-like shadow. The figures very probably represent Ernst himself and his father and the whole work relates to Ernst's difficult childhood relationship with his father. The use of a conventional religious title for this Freudian picture is a characteristic Surrealist attack on religion, in this case probably aimed specifically by Ernst at his father, who was a devout Catholic. (I am indebted to an unpublished lecture by Gabrielle Keiller for information on *Pietà*.)

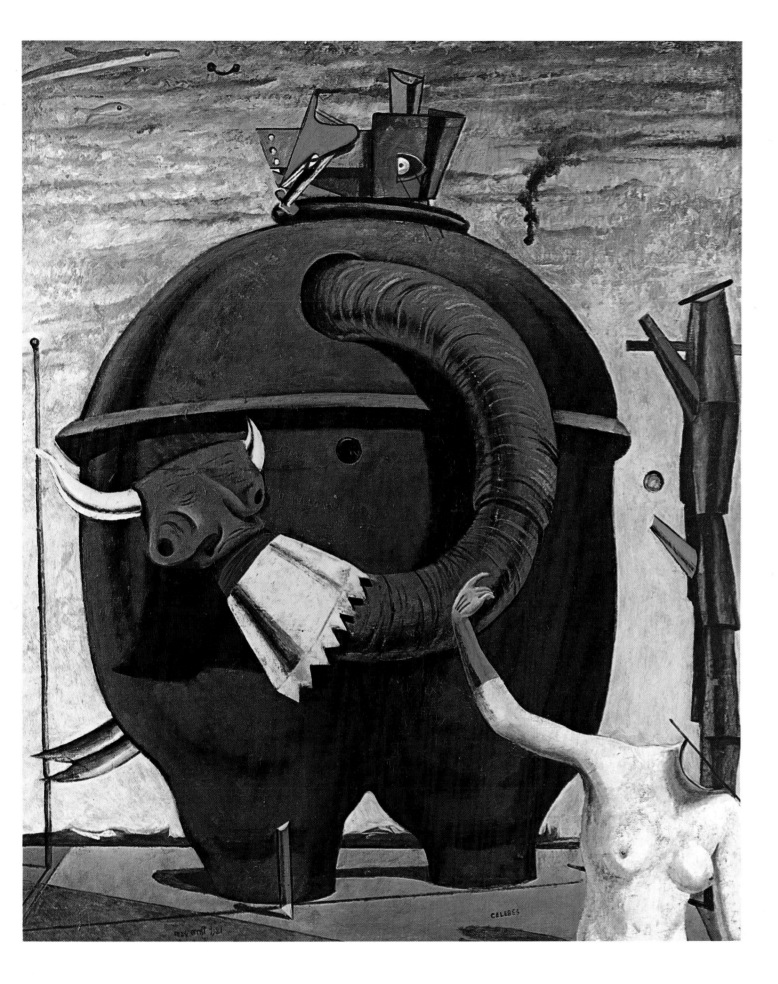

MAX ERNST (1891-1976)

Of This Men Shall Know Nothing

Oil on canvas, 81 x 64 cm. 1923. London, Tate Gallery

Fig. 14
MAX ERNST
At the First Clear
Word·

Oil on canvas,
232 x 167 cm. 1923.
Düsseldorf, Nordrhein-
Westfalen Collection

The inscription on the reverse of this work (Fig. 13) reveals that it was given by Ernst to André Breton at the time the first Surrealist Manifesto was being prepared. The poem may be seen as the equivalent of the painting in another medium. It also to some extent clarifies its extremely enigmatic imagery. 'The crescent (yellow and like a parachute) prevents the little whistle from falling to the ground. The little whistle, because someone is taking notice of him, thinks he might be going to the sun. The sun is divided in two to turn better. The model is extended in a dream pose. The right leg is bent (a precise and agreeable movement). The hand hides the earth. By this gesture the earth becomes a female sex. The moon runs through its phases and eclipses at top speed. The painting has a curious symmetry. The two sexes balance one another'. The 'model' is in fact a copulating couple. However, turned sideways its true 'symmetry' is revealed: it is composed of the lower limbs of a single figure combined with its mirror image. Geoffrey Hinton has shown that this painting, like *Pietà* , is partly based on sources in Freud.

At the First Clear Word (Fig. 14) is one of a remarkable series of decorations· done by Ernst in the house of his Surrealist friend Paul Éluard, while living with him in 1923-4. Note the ambiguous erotic imagery of the hand.

Fig. 13
MAX ERNST
Inscription on
reverse of 'Of This
Men Shall Know
Nothing'

London, Tate Gallery

MAX ERNST (1891-1976)

The Equivocal Woman (also known as 'The Teetering Woman')

Oil on canvas, 130 x 97 cm. 1923. Düsseldorf, Nordrhein-Westfalen Collection

Fig. 15
MAX ERNST
Two Children are
Threatened by a
Nightingale

Oil on wood with wood
construction,
70 x 57 x 11 cm. 1924.
Collection, The Museum
of Modern Art,
New York. Purchase

Here Ernst carries over into the dreamscape of early Surrealism one of the central features of Dada art – the invention of fantastic machines that parody the human body and human behaviour. The two elements of the machine gripping the woman suggest wooden trouser legs with large brown shoes on the feet and as with many Dada machines the function of this one appears to be erotic. The woman gasps and her hair stands straight up on end.

Two Children are Threatened by a Nightingale (Fig. 15), wrote Ernst in his autobiography, is 'the last in the series which started with *Celebes* . . . and probably the last consequence of his early collages – a kind of farewell to a technique'. However, it also indicates that after a period of pure painting he was experimenting once again with technique, and the use of found objects in this work seems to point towards his imminent development of the frottage technique (see Introduction and Plates 10 and 12). There is no accepted interpretation of this celebrated work. It is possible that the theme of menace from the sky is again associated with Ernst's wartime experiences. Ernst did however say that the work was inspired by one of his own prose poems which began: 'At nightfall on the outskirts of the town, two children are threatened by a nightingale'.

JOAN MIRÓ (1893-1983)

Maternity

Oil on canvas, 92 x 73 cm. 1924. Private Collection

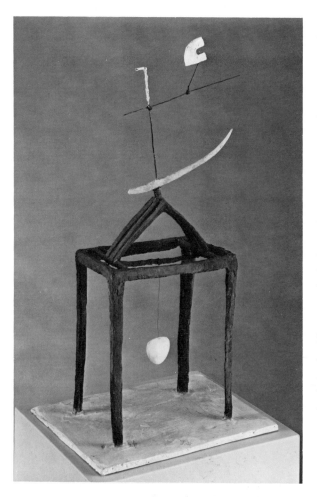

A masterpiece from the very beginning of Miró's Surrealist period, the year of the Manifesto. In it Miró's 'biomorphic' language of biological signs and symbols is fully developed with all the lightness, wit and pure fantasy that was to remain a central characteristic of his art. For Miró the imagery here is relatively straightforward: the woman in her fan-shaped skirt has a child feeding at each breast. She floats in a blue space that could be sea or sky.

Giacometti in his Surrealist sculptures seems to be developing a similar biomorphic language and like Miró he seems to be operating in an extremely spontaneous or 'automatic' way, as he himself has vividly described: 'For some years I have only made sculptures that were complete in my mind's eye. I have limited myself to reproducing them in space without changing anything and without stopping to ask myself what they might mean.' He also vividly evokes how such emanations from the unconscious may only afterwards be recognized: 'But once the object is finished, I can sometimes recognize images, impressions and experiences – transformed and displaced . . . ' He has however offered no comment on the imagery of *L'Heure des Traces* (Fig. 16). Diego, Giacometti's brother, who owned the work for many years, sees the hanging element as both clock pendulum and heart. It also strongly suggests the female pubic form. He sees the upper forms as celestial bodies. The critic Reinhold Hohl has convincingly also described the upper part with its phallic spike as 'a male skeleton figure' and sees it as having 'an expression of suffering'. In sum it appears a classic piece of Surrealism with its enigmatic and multi-layered references to male and female, disturbed emotional states and the mystery of time and space.

Fig. 16
ALBERTO
GIACOMETTI
'L'Heure des
Traces' (Hour of
the Traces)

Painted plaster and metal
rods, 68.5 x 36 x 28.5 cm.
1930. London, Tate
Gallery

JOAN MIRÓ (1893-1983)

The Birth of the World

Oil on canvas, 251 x 200 cm. 1925. Collection, The Museum of Modern Art, New York. Acquired through an anonymous fund, the Mr and Mrs Slifka and Armand G. Erpf funds, and by gift of the artist

This monumental work is the acknowledged masterpiece of Miró's Surrealist period and shows his technique at its most 'automatic'. Even in reproduction it can clearly be seen that the paint has been poured and dripped onto the lightly primed canvas in order to evoke a fluid primordial space, and that this has been followed by the rapid execution of a few biomorphic forms. In the recently published results of conversations with W. S. Rubin, Miró has shed interesting new light both on his procedures in this work and on its iconography: 'One large patch of black in the upper left seemed to need to become bigger. I enlarged it and went over it with opaque black paint. It became a triangle, to which I added a tail. It might be a bird.' The red disk with yellow tail is apparently a shooting star. In the lower left is a personage with a white head and pointed foot which almost touches a black spider-like star. Miró has spoken of the picture as 'a kind of genesis' and although its title was, Miró recalls, invented by either André Breton or Paul Éluard it was very much in what he felt to be the spirit of the painting.

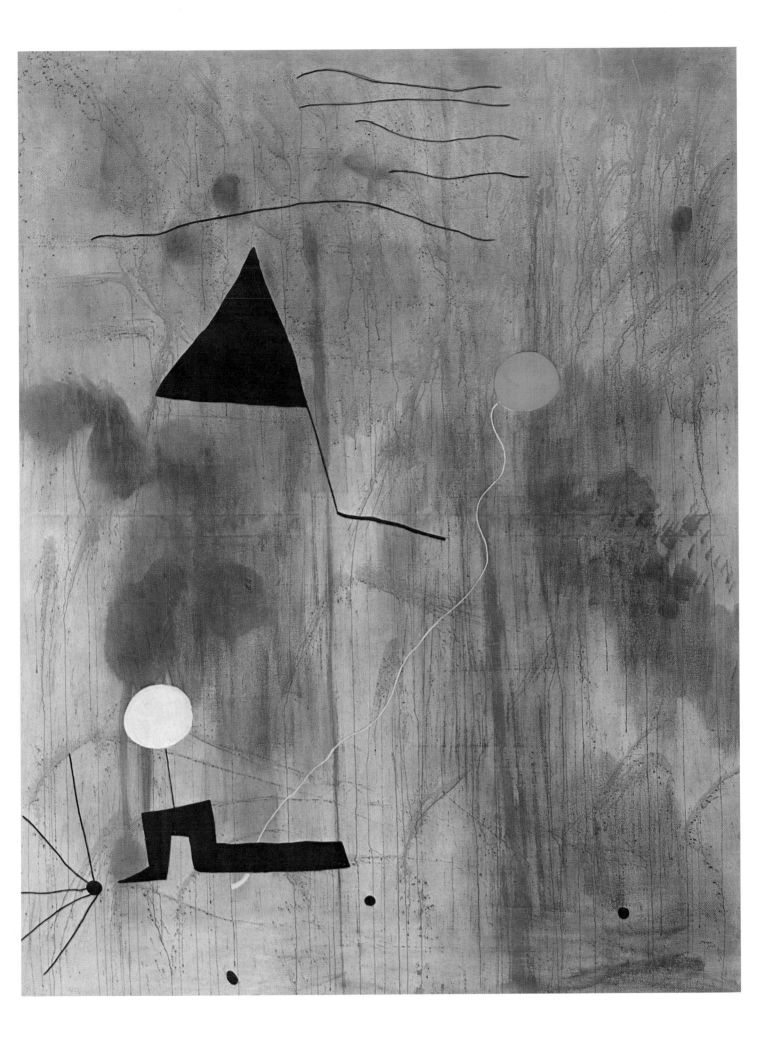

JOAN MIRÓ (1893-1983)

Stars in Snails' Sexes

Oil on canvas, 130 x 97 cm. 1925. Düsseldorf, Nordrhein-Westfalen Collection

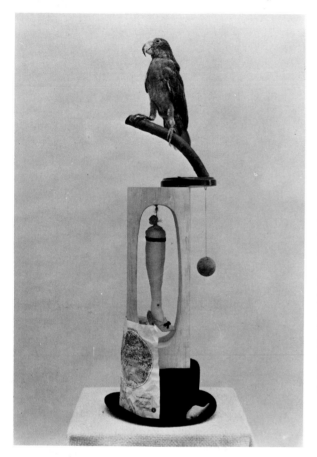

Fig. 17
JOAN MIRÓ
Object

Assemblage,
81 x 30 x 26 cm. 1936.
Collection, The Museum
of Modern Art, New York.
Gift of Mr and Mrs Pierre
Matisse

One of a substantial number of Miró's paintings of the Surrealist period which prominently feature poetic verbal statements written in a free flowing calligraphy that makes them as significant visually as verbally. Surrealism started as a movement of poets; poetry and the idea of it as analogous to painting remained of central importance to the Surrealist painters and to none more than Miró: in 1936 he said, 'What counts is to lay bare the soul. Painting or poetry are made as one makes love; an exchange of blood, a total embrace, reckless and unprotected.' The researches of Margit Rowell have established that Miró was steeped in modern poetry in the 1920s and that it often seems to form part of the frame of reference of his work at that time. She suggests some lines by the Dada poet Tristan Tzara 'a white very white light flee sun and stars snail' in connection with this painting. The imagery itself seems clear enough: a shooting star is flying through a red circle which is presumably the (female) sex organ of the snail. It seems a marvellous example of the extraordinary heights of poetic fantasy Miró could reach.

Miró's *Object* (Fig. 17) is a classic example of this form of Surrealist art (see Introduction). According to W. S. Rubin, Miró concurs with an interpretation which sees the work as a complex of thoughts or associations emanating from the head of the man whose hat forms the base of the whole. The fish and the map suggest the vast oceanic expanses of the mind. The fetishistic suspended woman's leg obviously represents erotic obsessions as probably does the suspended ball, which echoes similar elements in certain of Giacometti's sexually symbolic Surrealist sculptures. The symbolism of the parrot remains obscure.

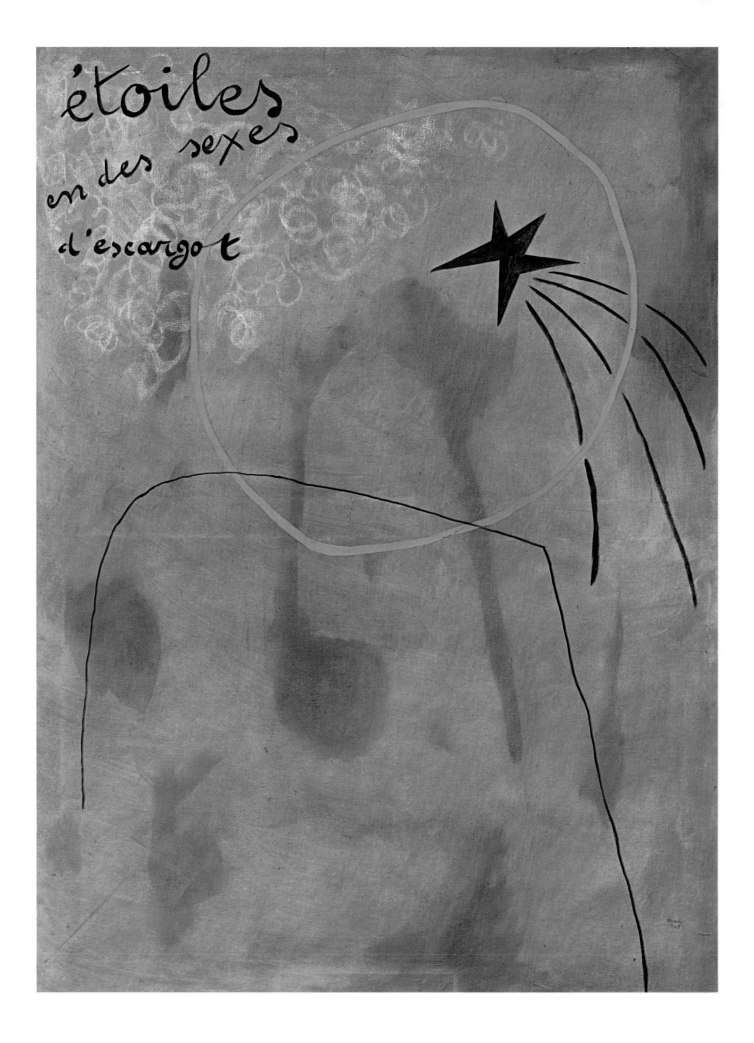

JOAN MIRÓ (1893-1983)

Photo: This is the Colour of My Dreams

Oil on canvas, 96 x 130 cm. 1925. Private Collection

One of the most enigmatic and compelling of Miró's poetic paintings and unusual in the dominance of the inscription over any other imagery. Roland Penrose has suggested that Miró's interest in the visual character of words and in their magic or incantatory qualities stems from a long Catalan tradition and cites the way in which Catalan peasants decorate their carts with arabesques and with their names and other inscriptions.

There is no agreement on the precise significance of the word 'Photo'; it seems to act as a title to the 'poem' *'ceci est la couleur de mes rêves'* and it may have the obvious meaning that we are being presented with, so to speak, a photograph of the colour – and shape – of Miró's dreams. However, the significance of the text clearly lies both in the reference to dreams, whose importance to the Surrealists has already been mentioned (see Introduction), and in the colour blue itself and Miró's use of it. The association of blue with dreams seems quite logical – it is the colour of the sky, of heaven, of space. It is also a colour with optimistic, lyrical and ecstatic associations. Many of Miró's paintings of the Surrealist period have extensive blue grounds, Plate 8 is a good example, so if blue is the colour of his dreams these are indeed dream paintings.

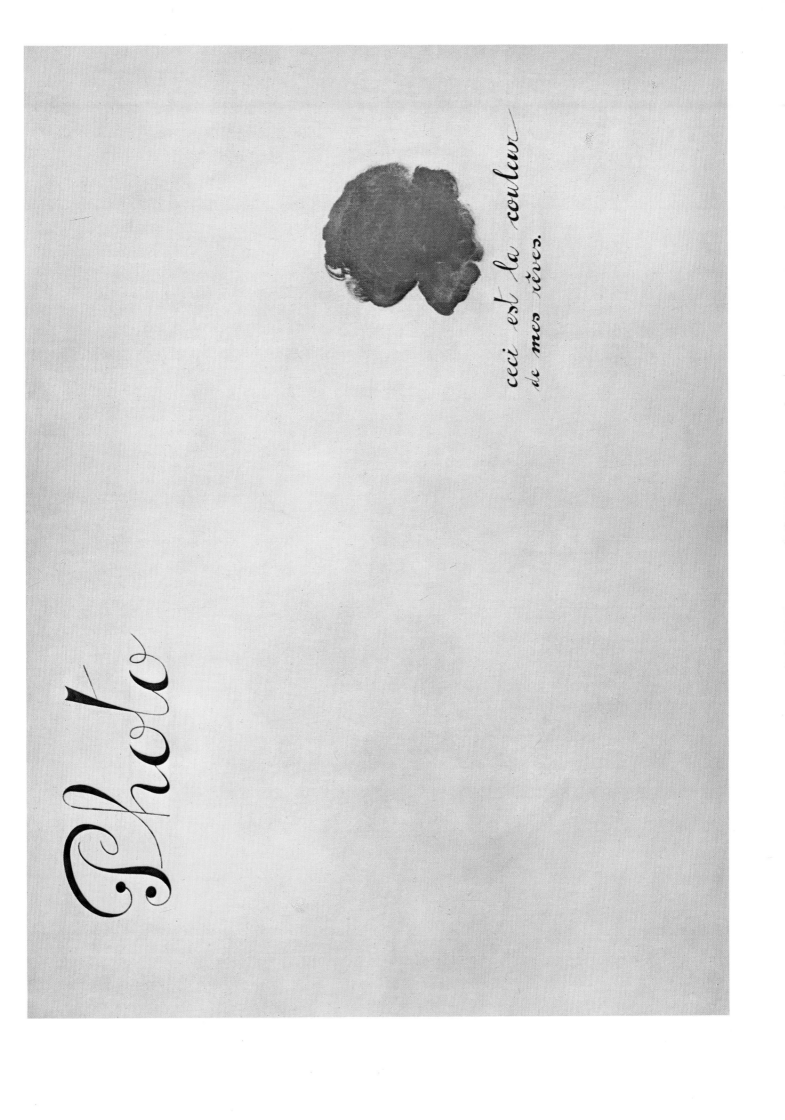

ceci est la couleur de mes rêves.

Photo

JOAN MIRÓ (1893-1983)

Painting

Oil on canvas, 97 x 130 cm. 1927. London, Tate Gallery

Margit Rowell (see note to Plate 6) has made the very interesting sugges-
tion that part of the frame of reference of this work is the poet
Apollinaire's play *Les Mamelles de Tirésias* ('The Breasts of Tiresias') first
performed in 1917, which Apollinaire subtitled *'drame surréaliste'* – the
first use of the word. In this fantasy Tirésias becomes a woman and pro-
duces 40,049 babies in a single day – at the opening of the second act the
stage is scattered with numerous cradles. At the end his wife Thérèse
releases a bunch of balloons saying 'go and feed all the children of the
repopulation'. On the right of the painting is a red-nippled breast with
what might be a balloon rising beside it. The brown form can be seen as
a mouth feeding at the breast. The circular form with a red spot at the
top could be another breast/balloon. If these images do stem from Miró's
memories of Apollinaire's play, he has also succeeded in universalizing
the play's theme of reproduction: the balloon at lower right is also a
sperm, the breast beside it also a phallus penetrating the brown tunnel-
like form. Within the breast the black form appears unmistakably
uterine. The circle with a red spot suggests an ovum, perhaps with its
nucleus about to be fertilized by the black cell hovering at its rim.
Elsewhere in the painting are primitive, leech-like forms and the overall
effect, apart from the white form, is one of life burgeoning in the
primeval sea or space. According to Sir Roland Penrose, Miró identifies
the white shape as a circus horse, which relates it to a number of Miró's
works inspired by the circus, a favourite entertainment of the Surrealists.

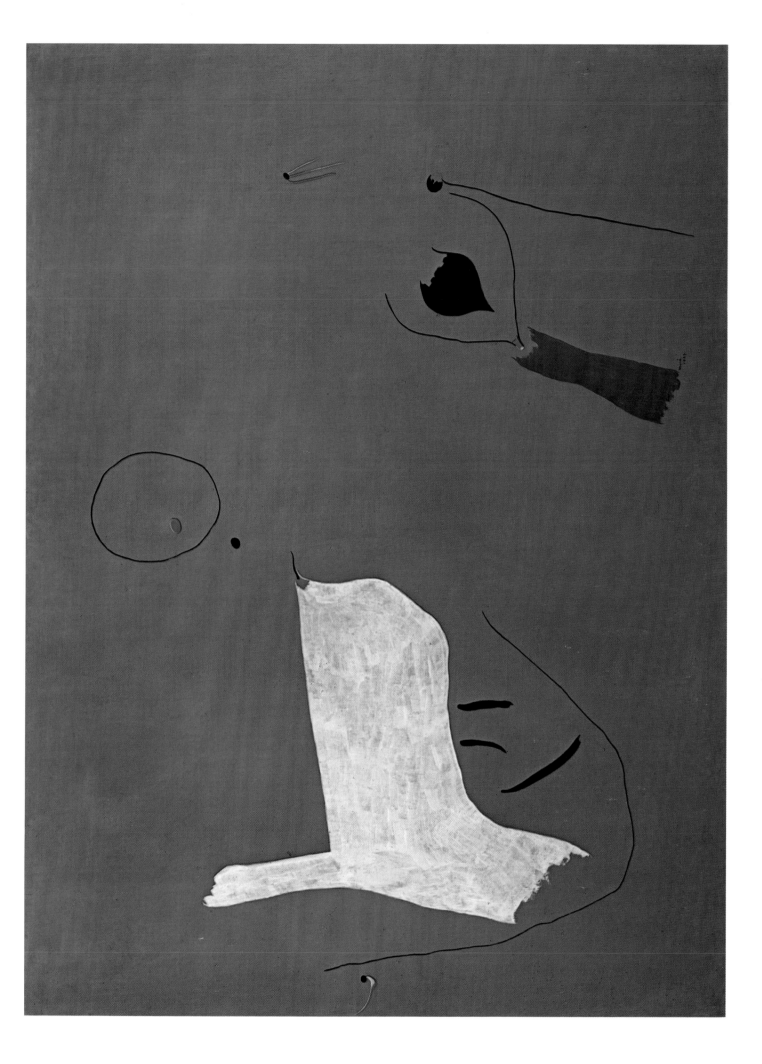

ANDRÉ MASSON (b. 1896 - 1987)

Battle of Fishes

Sand, gesso, oil, pencil and charcoal on canvas, 36 x 73 cm. 1926. Collection,
The Museum of Modern Art, New York. Purchase

One of the best known of Masson's sand paintings. (His method of mak-
ing them and their place in the development of Surrealist painting is
described in the Introduction) In common with almost all automatic
Surrealist painting Masson's sand paintings evoke some aspect of a
primeval world where burgeoning life struggles for existence. Masson
himself has said that 'the fish are anthropomorphic and curiously enough
at that time an American writer I had never hear of, H. P. Lovecraft, had
imagined or believed he had seen (because he was undoubtedly a vision-
ary) a human population issue from couplings of women with fish'.
However as the historian of Surrealism W. S. Rubin has suggested, the
imagery of this painting is also strikingly reminiscent of a passage in that
bible of the Surrealists, *Les Chants de Maldoror*, in which the hero
Maldoror, after a shipwreck, observes a great shoal of sharks battling over
the human bodies in the sea and finally himself swims out and couples
with the victor, a huge female. The savage fish in the top right corner of
the painting has what might be a limb in its jaws, though apart from this
the anthropomorphism is difficult to see.

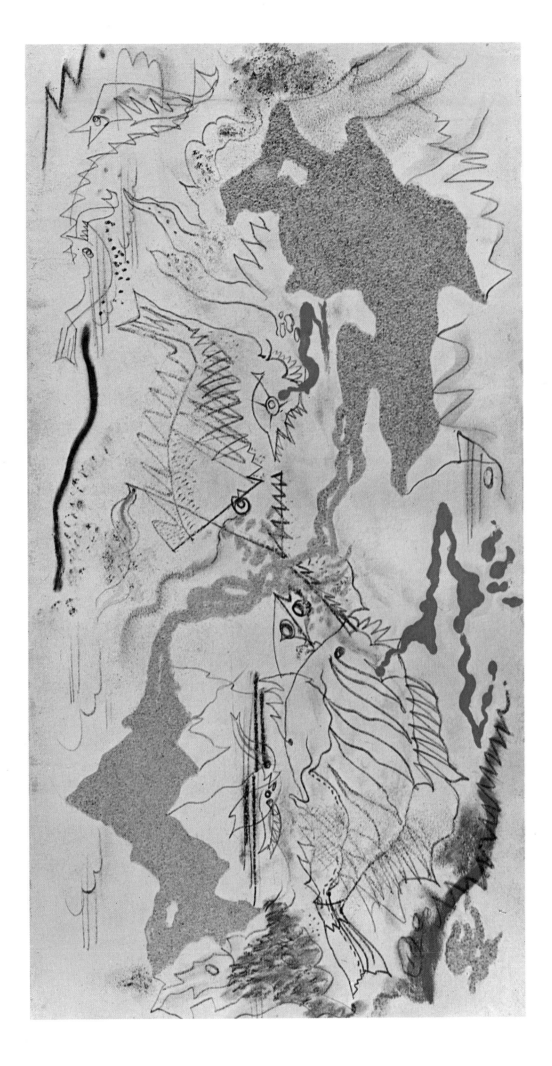

MAX ERNST (1891-1976)

The Whole City

Oil on canvas, 60 x 81 cm. 1935. Zurich, Kunsthaus

In the *City* paintings Ernst introduces a new element into his brooding vision of the forest: fantastic terraced cities, ruined (not entire in spite of the title), unimaginably ancient, relics of lost or even alien civilizations, presided over by haunting mysterious suns. Here at the base of the long-dead city luxuriant and exotic plant-growth flourishes and the whole becomes a symbol of the cycle of life. It has also been suggested by U. M. Schneede that these paintings can now be seen as prophetic of the destruction that came to European cities in the 1939-45 war.

Showing the Head of her Father to a Young Girl (Fig. 18) is one of the most powerful and monumental of the early *Forest* paintings. The vision of the forest is here completed by Ernst's compelling symbol of the giant sun, but, unique among the *Forests*, in the foreground a terrifying and disturbing psychodrama is being enacted. The symbolism of this drama is highly complex but as in *Pietà* (Fig. 12) one point of departure is probably Ernst's problematic relationship with his father and consequent obsession with Freud's concept of the Oedipus complex: the severed head with its upturned moustaches closely resembles the father figure's head in *Pietà*. Here, however, Ernst may be referring to the feminine aspect – the Electra complex (named after Electra, whose father was murdered by her mother). Also evoked is the enduring myth of the *femme fatale;* iconographically this is Salome receiving the head of John the Baptist, although that other biblical murderess Judith, who actually severed her victim's head, also comes to mind. The disturbing sexuality expressed is pointed up by the bizarre gesture of the hand holding the head, taken of course from the celebrated erotic masterpiece in the Louvre, much beloved by the Surrealists, which shows Gabrielle d'Estrée and her sister in the bath, one pinching the other's nipple between thumb and forefinger.

Fig. 18
MAX ERNST
**Showing the Head
of her Father to a
Young Girl**

Oil on canvas,
65.5 x 81.5 cm. 1926.
Private Collection

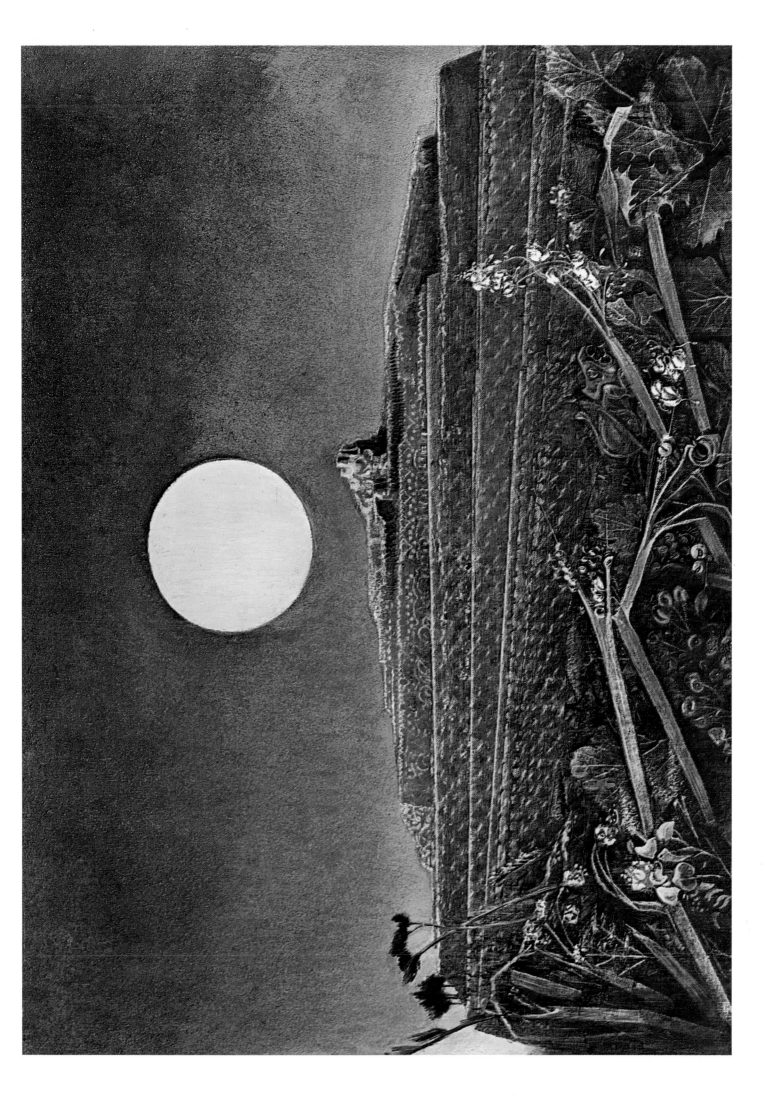

MAX ERNST (1891-1976)

Europe after the Rain

Oil on canvas, 54 x 146 cm. 1940-2. Wadsworth Atheneum, Hartford, Connecticut.
Ella Gallup Sumner and Mary Catlin Sumner Collection

After the outbreak of World War II Ernst was twice interned by the French as an enemy alien. He was eventually released in the early summer of 1940 and began to paint *Europe after the Rain* at his home in Saint Martin D'Ardèche near Avignon. In 1941 he escaped from the Gestapo to the United States and completed the picture in New York.

This is one of a group of paintings which clearly reflect the artist's wartime experiences in their general pessimism. Ernst here presents a fantastic vision of a shattered world with a lone warrior standing beside his crushed warhorse, isolated amidst the ruins. The 'rain' of the title perhaps refers to the rain of bombs that devastated Europe in the latter stages of the war.

The richness, the encrusted mineral quality of this painting, comes partly from Ernst's use in its early stages of the automatic technique of decalcomania, which involves pressing thin paint on to the canvas with a sheet of glass or other smooth surface. The spreading of the paint produces curious textures and configurations, best seen in the rock formations on the left.

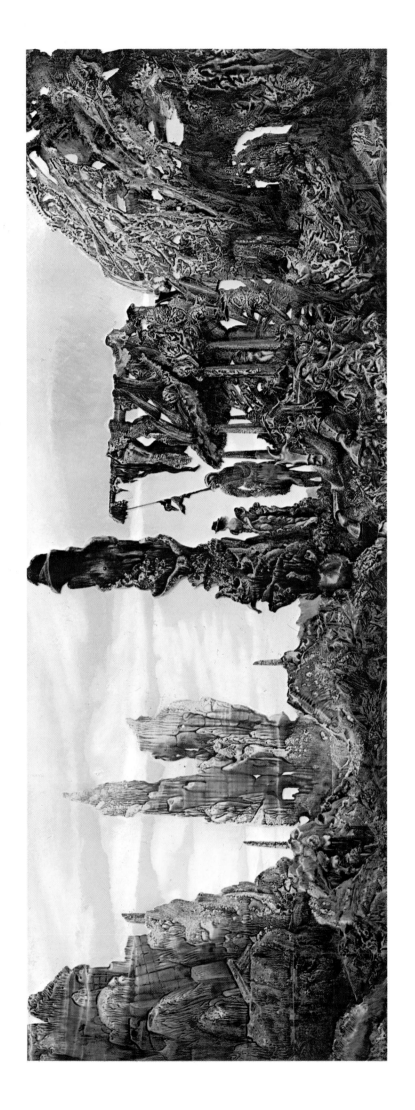

MAX ERNST (1891-1976)

Forest and Dove

Oil on canvas, 100 x 82 cm. 1927. London, Tate Gallery

This is one of the so called *Forest* paintings that Ernst executed at intervals between 1926 and 1933. As a group they constitute the most important early manifestation of the frottage technique and also perhaps mark the summit of his achievement as a painter. They are a distinguished addition to an important German tradition of poetic and visionary painting of forests which goes back through the great Romantic painter Caspar David Friedrich to the sixteenth-century Altdorfer. Their brooding imagery may be related to the fact of Ernst's childhood home being near a forest and in particular to an incident recounted by Ernst in his autobiography (written in the third person). At the age of three his father took him into the forest for the first time and 'Max never forgot the enchantment and terror he felt . . . Echoes of this feeling can be found in many of Max Ernst's own *Forests, Visions, Suns* and *Nights.*' In *Forest and Dove* the presence of the innocent dove, sole evidence of life, emphasizes the feeling of fear and solitude. Indeed there is a suggestion of a cage drawn around the bird. In 1933 after completing the largest of the *Forests* Ernst wrote a prose poem, *The Mysteries of the Forest*, which was published in issue 5 of the Surrealist orientated magazine *Minotaure*: 'Man and the nightingale found themselves in the most favourable position for imagining: they had in the forest a perfect guide to dreams.'

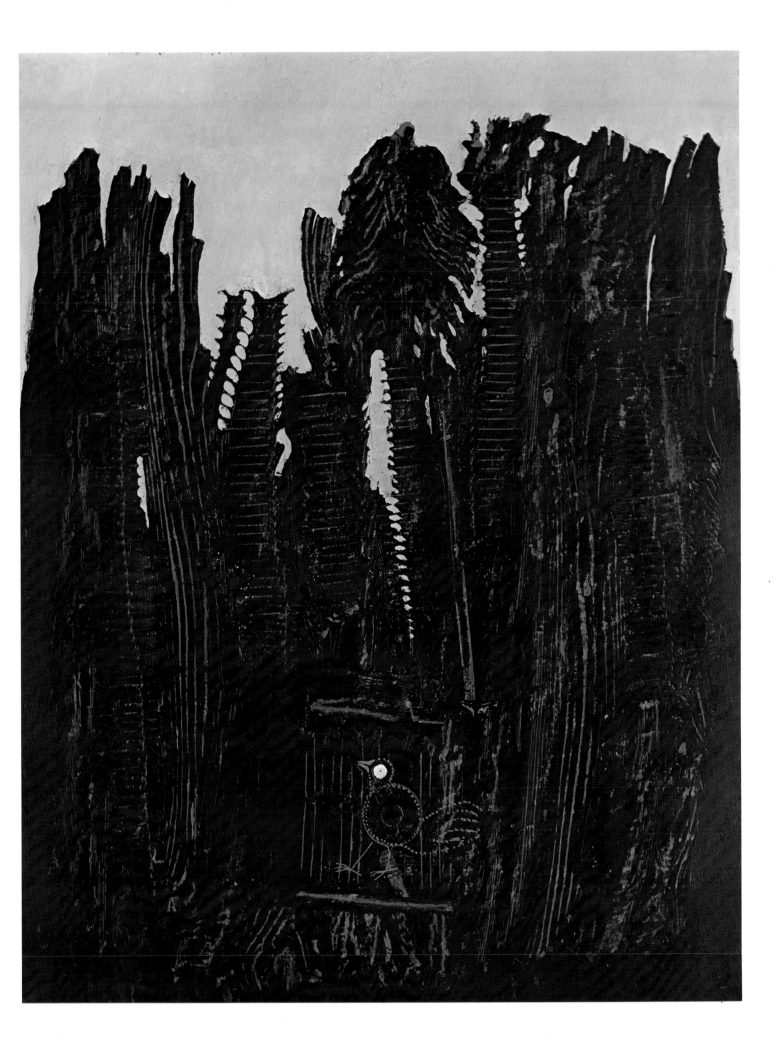

PABLO PICASSO (1881-1973)

The Three Dancers

Oil on canvas, 215 x 142 cm. 1925. London, Tate Gallery

The basic atmosphere of this remarkable painting is one of primitive sexuality and violence, basic themes, as we have seen, of Surrealist art. The figure on the left is an image of woman as a kind of savage sexual being: Picasso has strongly emphasized her sexual attributes, grotesquely distorting her left breast and treating the other in such a way that, disturbingly, it also reads as an eye. Worn almost like a badge on the outside of her short striped skirt is a large graffiti-like image of her sexual parts. Her partly eroded or decayed head displays a mouth full of sharp pointed teeth. The figure in the centre is unmistakably crucified, thus evoking suffering, death and perhaps martyrdom. The unconscious feelings expressed in this work are jaggedly apparent both in its imagery and in the harsh quality of its line, colour and texture. But it is also an extremely interesting example of a Surrealist work where autobiographical revelations by the artist have made possible a more detailed interpretation. In 1965, when the Tate Gallery acquired this work directly from the artist, Picasso told the English Surrealist Sir Roland Penrose, who had helped in the negotiations, 'While I was painting this picture an old friend of mine, Ramon Pichot, died and I have always felt that it should be called *The Death of Pichot* rather than *The Three Dancers*. The tall black figure behind the dancer on the right is the presence of Pichot.' It appears that the original painting of three ballet dancers (Picasso was very involved with Diaghilev's ballet at this time) was transformed into its present state after the death of his friend. He added the black profile of Pichot, altered the central figure to look crucified and radically changed the woman on the left, twisting the body backwards and adding the grotesque breasts, vulva and savage mask-like head. The actual handling of the paint suggests that these changes were made with some urgency and it is this unpremeditated quality – the sense of feeling being directly incorporated into line, form and texture, the degree of automatism, it might be said – which as much as the content must have struck Breton and the other Surrealists. Further autobiographical revelations illuminate the role of the savage woman dancer in this painting. In 1910, just before her marriage, Pichot's wife, Germaine, had a disastrous love-affair with another of Picasso's friends Carlos Casagemas, who shot himself after being rejected by her. Picasso may have had this memory somewhere in mind when he created the primitivistic *femme fatale* of *The Three Dancers*.

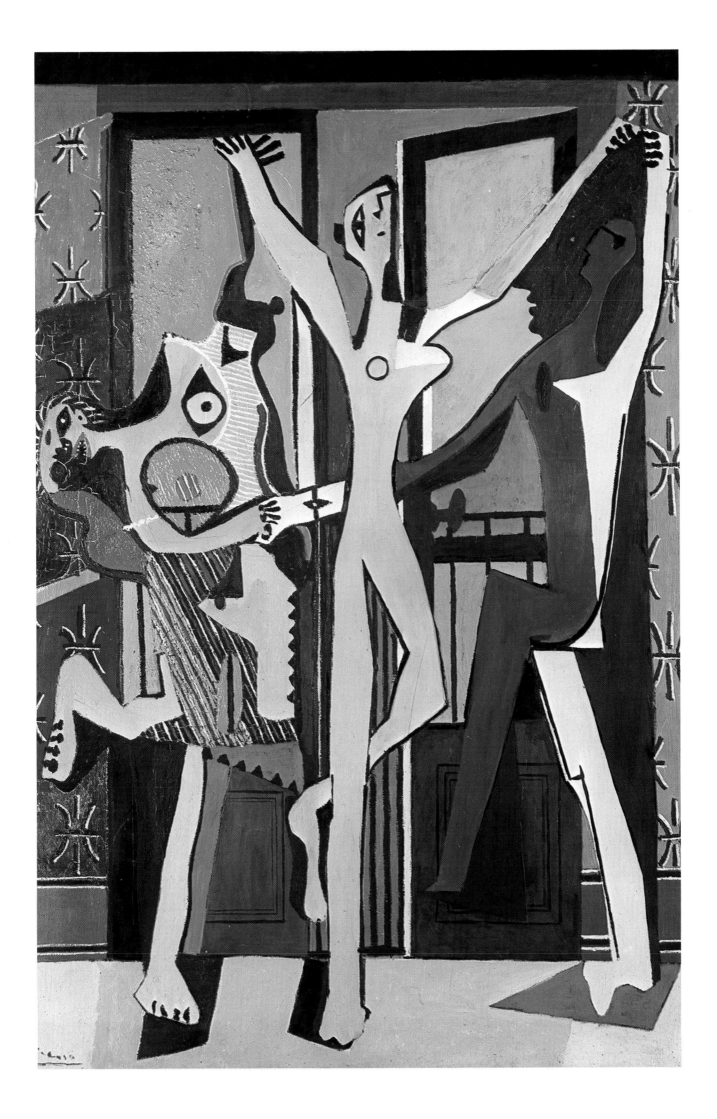

Nude Woman in a Red Armchair

Oil on canvas, 130 x 97 cm. 1932. London, Tate Gallery

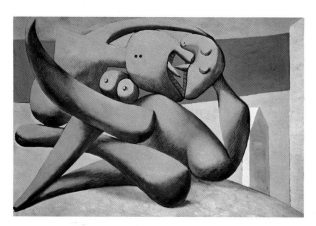

Fig. 19
PABLO PICASSO
Figures by the Sea

Oil on canvas,
130 x 195 cm. 1931.
Private Collection

Juxtaposed with *The Three Dancers* (Plate 13) this work demonstrates the great expressive range of Picasso's art during his 'Surrealist' period. In it the anguish and savagery of the earlier painting is replaced by a lyrical eroticism. *Nude Woman in a Red Armchair* is in fact one of a group of paintings by Picasso, considered by many to be among his greatest works, which were inspired by his love for Marie-Thérèse Walther, a girl he met in Paris early in 1932 when she was seventeen. They embarked upon what on the evidence of these paintings was an affair of intense and joyful passion and Marie-Thérèse eventually bore Picasso's daughter Maïa.

In this painting Picasso has rendered the girl's figure as a system of voluptuous curves, a system to which the arms and upholstery of the chair also conform save for the necessary contrast of the straight back. By this period Picasso was a complete master of the metamorphic image, the image that refers simultaneously to more than one thing (a device of great interest to the Surrealists). Here, for example, he has painted both of the girl's arms in such a way that they also represent other parts of the body: the upper, right, arm suggests a view of the buttocks and thighs as if she were curled up and lying on her side; the hand is treated somewhat like a fish-tail and the whole image also suggests that popular object of erotic fantasy, the mermaid (compare Fig. 19). The other arm represents an even more intimate view of her anatomy, as if she were lying on her back with legs up and apart. The cleft of the elbow becomes the pubic region, above which is an extraordinary passage of thick, creamy-white paint. But the most remarkable aspect of this painting is the treatment of the head. Picasso has constructed it by combining a full face and profile view. The effect of this is to make a head which both conforms to the basic compositional system of rounded and curving rhythms and suggests romantic references to the moon. However, the right-hand profile side of the head can also be seen as a separate face, leaning over the back of the chair and kissing the mouth of the seated girl. It is irresistible to see this as the presence of Picasso himself and suggests the merging of their two personalities.

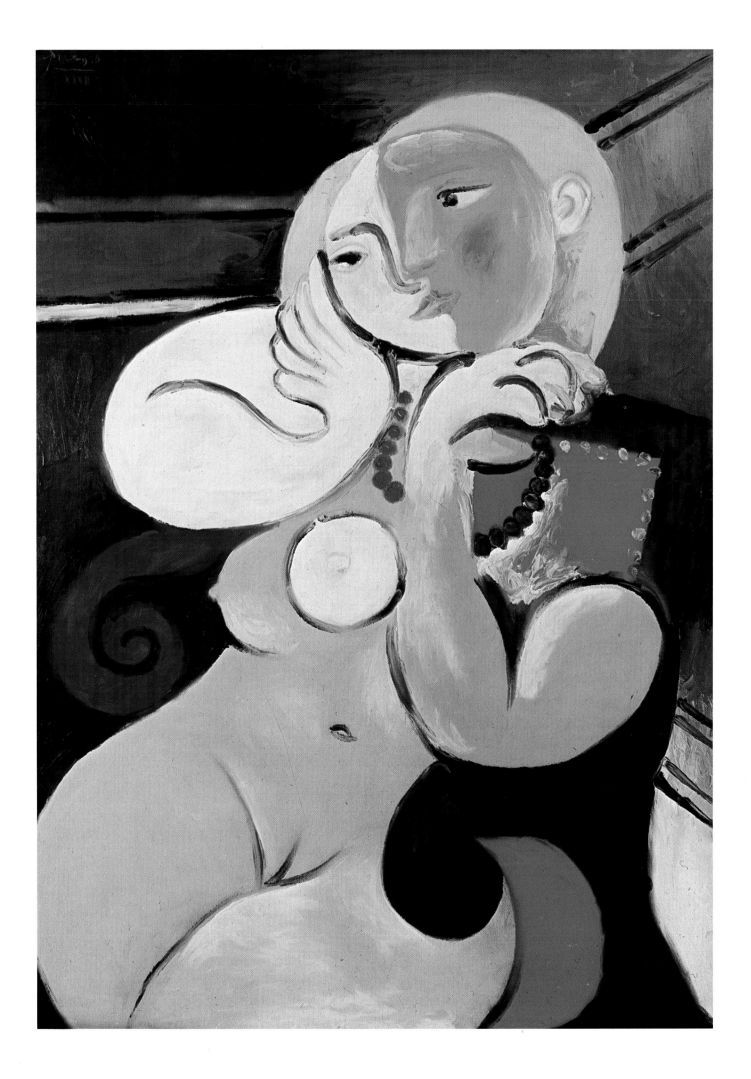

The Reckless Sleeper

Oil on canvas, 116 x 81 cm. 1927. London, Tate Gallery

Fig. 20
RENÉ MAGRITTE
The Treason of
Images

Oil on canvas, 62 x 81 cm.
1929. Los Angeles County
Museum of Art

This is one of many works of Surrealist art which contain explicit references to sleep and to dreams. In this case it may be suggested that the lower part of the composition represents the dream of the sleeper. The grey area might be a profile of a head with the dream thoughts embedded in it. However it also resembles a gravestone and the man's box a coffin, so the painting also becomes evocative of death. The title may mean that it is a reckless act we perform every night when we go to sleep and expose ourselves to the strange world of dreams.

Also reproduced here (Figs. 20 and 21) are two of a group of works Magritte made under the title *The Use of Words*. These early works mark the beginning of one of the most significant strands in his *oeuvre*, the investigation of the mysterious relationship between words and images. In one Magritte points up the essentially arbitrary nature of this relationship: 'any shape whatever may replace the image of an object', as he put it in his illustrated essay *Words and Images*, published in the Surrealist magazine *La Révolution Surréaliste* in December 1929. The celebrated painting of a pipe bearing the legend *'Ceci n'est pas une pipe'* ('This is not a pipe') deals with one of the central and most significant preoccupations of modern painting – the relationship between a real object and its representation on canvas. We commonly speak of 'realism' in painting although all 'realistic' representation of tangible objects in painting is in fact a form of illusionism.

Fig. 21
RENÉ MAGRITTE
The Use of Words

Oil on canvas,
54.5 x 73 cm. 1928.
Cologne, Galerie Rudolf
Zwirner

Pleasure

Oil on canvas, 74 x 98 cm. 1926. Düsseldorf, Nordrhein-Westfalen Collection

Although the tone of Magritte's work overall is cool and philosophic there are works by him like this one and *The Red Model* (Plate 18) which reveal that he shares the Surrealist fascination with the macabre and erotic. As with his colleagues, it seems likely that one of his sources of inspiration for such works was Lautréamont's *Les Chants de Maldoror* (see p.7), an edition of which, with no less than seventy-seven illustrations by Magritte, was published in Brussels in 1948. It has been suggested by Werner Schmalenbach, Director of the Nordrhein-Westfalen Collection, that this is a Surrealist reworking of the Garden of Eden myth, with Eve as a vampiric young girl and a live bird substituted for the apple. It also clearly appears as a powerful symbolic representation of loss of virginity, in which Magritte makes telling use of the vivid splashes of blood on the purity of the girl's white collar.

Mouvement Immobile (Fig. 22) is by Magritte's friend and supporter E. L. T. Mesens, who was a co-founder of the Surrealist group in Brussels and who later played a leading role in the Surrealist movement in London. Here he expresses something of the same preoccupation as Magritte with the relationship between words and images. In this collage the letters are arranged to form images that express the meaning of the word.

Fig. 22
E. L. T. MESENS
'Mouvement
Immobile II'

Collage and watercolour
on cardboard, 33 x 52 cm.
1960. London, Tate
Gallery

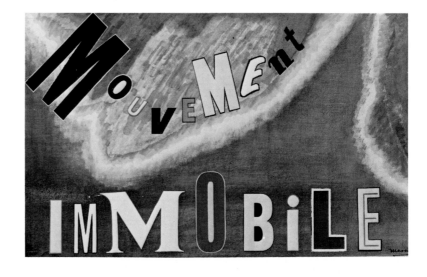

The Menaced Assassin

Oil on canvas, 150 x 195 cm. 1926. Collection, The Museum of Modern Art, New York.
Kay Sage Tanguy bequest

This painting may relate to the other literary work besides *Maldoror* which was a great favourite of the Surrealists, the popular thriller series *Fantômas*, published in thirty-two monthly parts between 1912 and 1914. Like *Maldoror*, *Fantômas* has an eponymous master-criminal hero. The Surrealists were particularly delighted by the way in which Fantômas always escaped the traps set for him by his great adversary Inspector Juve of the Sûreté. This painting seems to represent such an episode, with the criminal unconcernedly listening to music beside the naked corpse of his victim while his would-be captors gather round him.

A year or so after painting *The Menaced Assassin*, Magritte also wrote his own, surrealist, version of one of Juve's failed attempts to arrest Fantômas. Juve manages to tie up Fantômas while he sleeps, but: 'Juve, in the highest of spirits, pronounces some regrettable words. They cause the prisoner to start. He wakes up and once awake, Fantômas is no longer Juve's captive. Juve has failed again this time. One means remains for him to achieve his end: Juve will have to get into one of Fantômas's dreams.' (Quoted by Suzi Gablick in *Magritte*, London, 1970.)

RENÉ MAGRITTE (1898-1967)

The Red Model

Oil on canvas, 183 x 136 cm. 1934. Rotterdam, Boymans-Van Beuningen Museum

Fig. 23
RENÉ MAGRITTE
The Future of
Statues

Painted plaster bust,
33 x 16.5 x 20 cm. c.1937.
London, Tate Gallery

The Red Model is one of those paintings in which Magritte combines objects in such a way as to produce a new object which would be impossible in real life, but which, because it is painted in a convincingly representational way, nevertheless seems to be credible. The effect of such an image is to produce an intense sense of shock, bafflement and frustration: however hard you look the object refuses to resolve itself entirely into its components although both are clearly there. As is often the case with Magritte the title adds to the enigma by its apparent irrelevance to the image. Magritte himself seems to have seen this picture as a comment on the unnaturalness of wearing shoes: 'The problem of shoes demonstrates how the most barbaric things pass as acceptable through the force of habit. One feels, thanks to *The Red Model*, that the union of a human foot and a leather shoe arises in reality from a monstrous custom.' (Quoted by Suzi Gablick in *Magritte*, London, 1970.) *The Red Model* was painted for the great collector Edward James (see Introduction) and the King Edward VII penny in the left foreground may refer to the persistent rumour that James was an illegitimate son of the king.

The Future of Statues (Fig. 23) is a Surrealist object by Magritte which like *The Red Model* functions through the tensions set up by relating two utterly disparate realities. Its base is a plaster cast of Napoleon's death-mask.

Time Transfixed

Oil on canvas, 146 x 97 cm. 1939. Collection of the Art Institute of Chicago

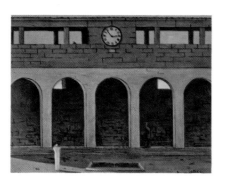

Fig. 24
GIORGIO
DE CHIRICO
The Enigma of
Time

Oil on canvas,
115.5 x 71 cm. 1911.
Private Collection

The Enigma of Time (Fig. 24) is a type of early de Chirico which must have had a particularly profound influence on Magritte: a straightforward reality made to appear intensely dreamlike and unreal. Furthermore its title announces an important theme of Surrealist art, the mystery of time, also dealt with in the two works by Magritte reproduced here. *Time Transfixed* relates to Breton's concept of convulsive beauty as exemplified by the stopped locomotive in the jungle (see Introduction, p.7). *Man with a Newspaper* (Fig. 25) is an image of time passing and specifically of mortality: the man is present in the first compartment, absent in the second and continues to be absent.

Fig. 25
RENÉ MAGRITTE
Man with a
Newspaper

Oil on canvas,
115.5 x 81 cm. 1928.
London, Tate Gallery

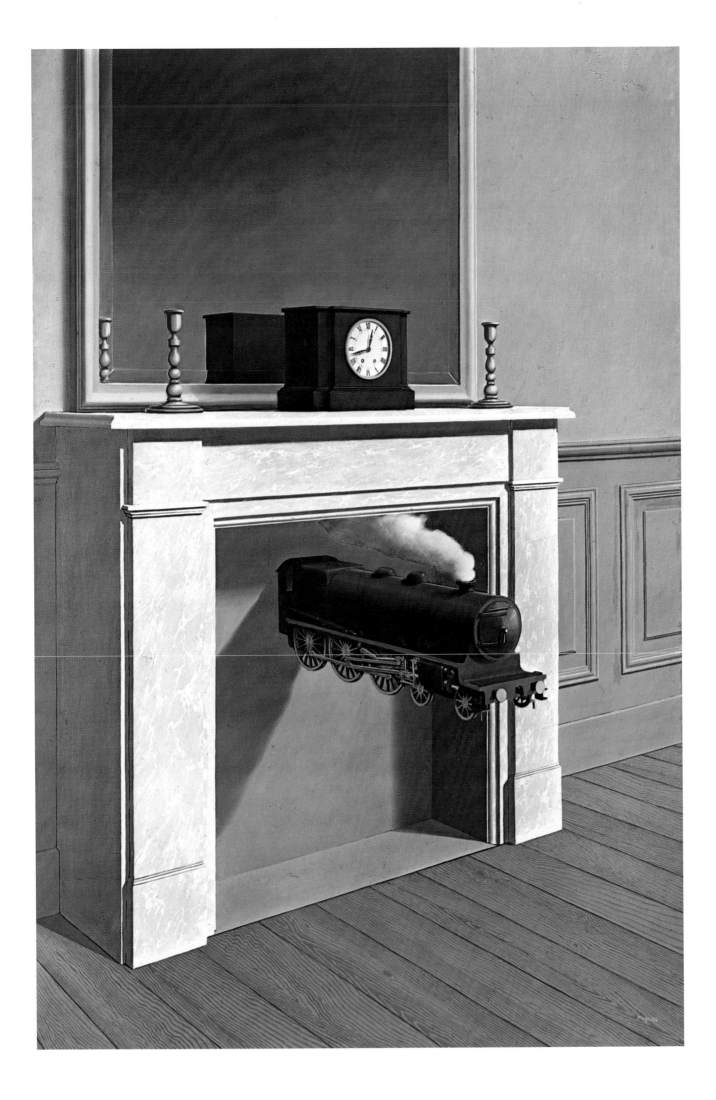

PAUL DELVAUX (b. 1897)

The Call of the Night

Oil on canvas, 113 x 133 cm. 1937. Private Collection

Paul Delvaux is a Belgian Surrealist painter who studied architecture and painting at the Académie des Beaux-Arts in Brussels and in 1925 had his first one-man exhibition. His painting at this time was essentially traditional in both form and content. However in 1936 he was introduced by E. L. T. Mesens to the work of de Chirico and Magritte and very quickly developed the manner for which he is now known. André Breton summed up his art perfectly when he wrote, 'The sap of Surrealism rises too from the great roots of dream life to nourish the paintings of . . . Paul Delvaux . . . ' His paintings are perhaps the most obviously dreamlike of all the Surrealists', frequently depicting dreaming or day-dreaming figures. *The Call of the Night* is one of his earliest masterpieces and remains among the most compelling of all his works. Here already fully fledged is Delvaux's great contribution to Surrealist imagery, the classical yet eroticized female nude. The painting expresses that fundamental Surrealist theme of the basic processes and cycles of life: the eroticism of the figures has as its necessary complement the intense fertility of the lush plant-growth which envelops them like a cape and links them to the mother earth. In the background the barren landscape is littered with emblems of death, although the burning tree must represent the renewal of life.

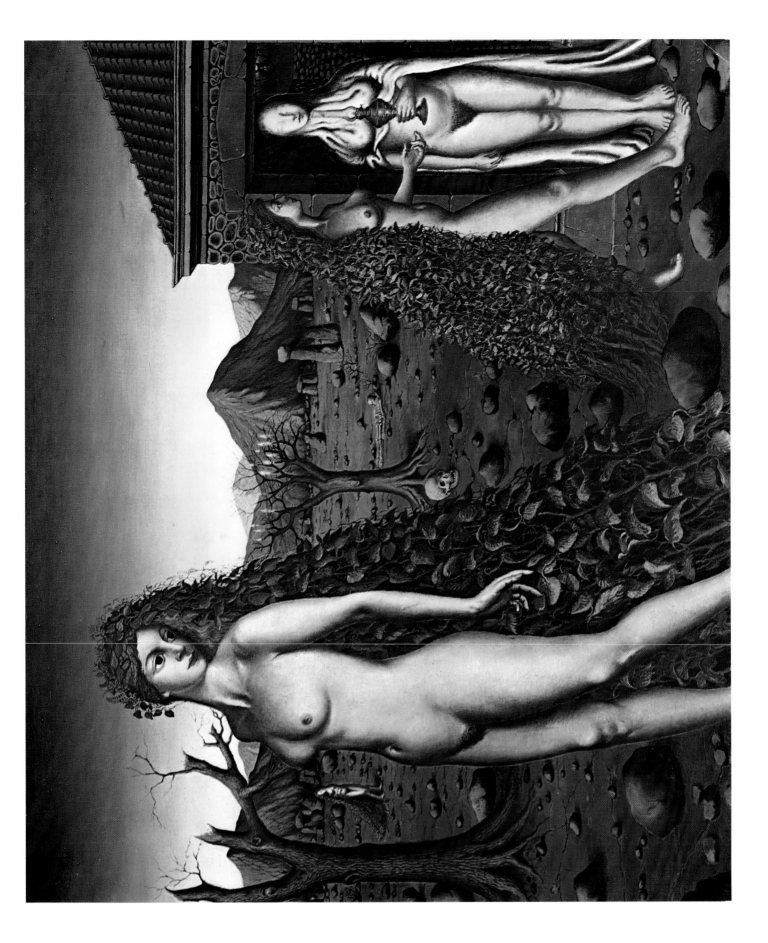

PAUL DELVAUX (b. 1897)

The Public Voice

Oil on canvas, 152 x 254 cm. 1948. Brussels, Musées Royaux

Many of Delvaux's scenes are set in a mysterious, apparently turn of the century city which the artist sometimes referred to as *La Ville Inquiète* ('The Uneasy City'). Of these paintings, which perhaps dominate Delvaux's *oeuvre*, Breton wrote, 'Delvaux has turned the whole universe into a single realm in which one woman, always the same woman, reigns over the great suburbs of the heart.' The influence of de Chirico is evident in Delvaux's development of this dreamlike cityscape, and the apparent irrelevance of the title of *The Public Voice* is reminiscent of Magritte, although Delvaux may have intended a play on the words public and pubic.

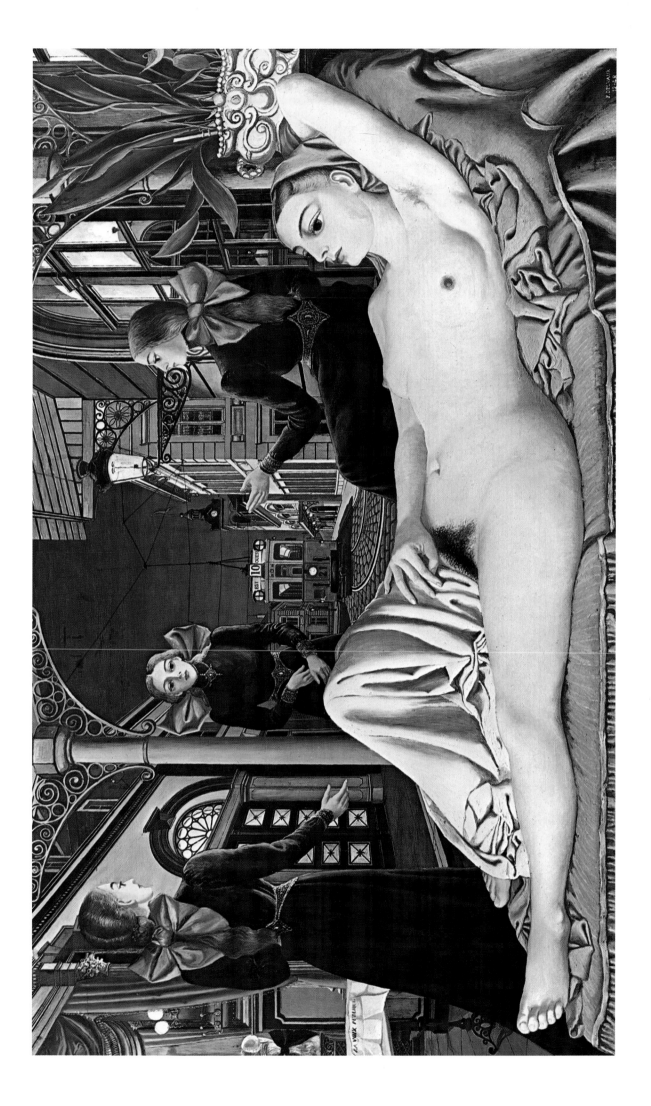

PAUL DELVAUX (b. 1897)

The Night Train

Oil on canvas, 153 x 210 cm. 1947. Private Collection

Finding beauty and magic in the urban environment was always an important aspect of the Surrealist sensibility. Railway stations and trains had a particular significance for Surrealist artists, as they had had for de Chirico before. Delvaux himself wrote: 'And then there is the nostalgia of waiting-rooms where people go past, departing, running away, leaving their own homes: the sad, abandoned, mournful feeling they have with their worn, threadbare, dusty and smoke-laden curtains and the barmaid behind her black counter with its bottles'. He might perhaps have added that because they are places of transit in which the normal realities of daily life are suspended, they are particularly conducive to erotic fantasy. The style of this waiting-room is very much Edwardian or *Belle Époque*, a style the Surrealists loved for its extravagance and especially for its quality of a vanished dream.

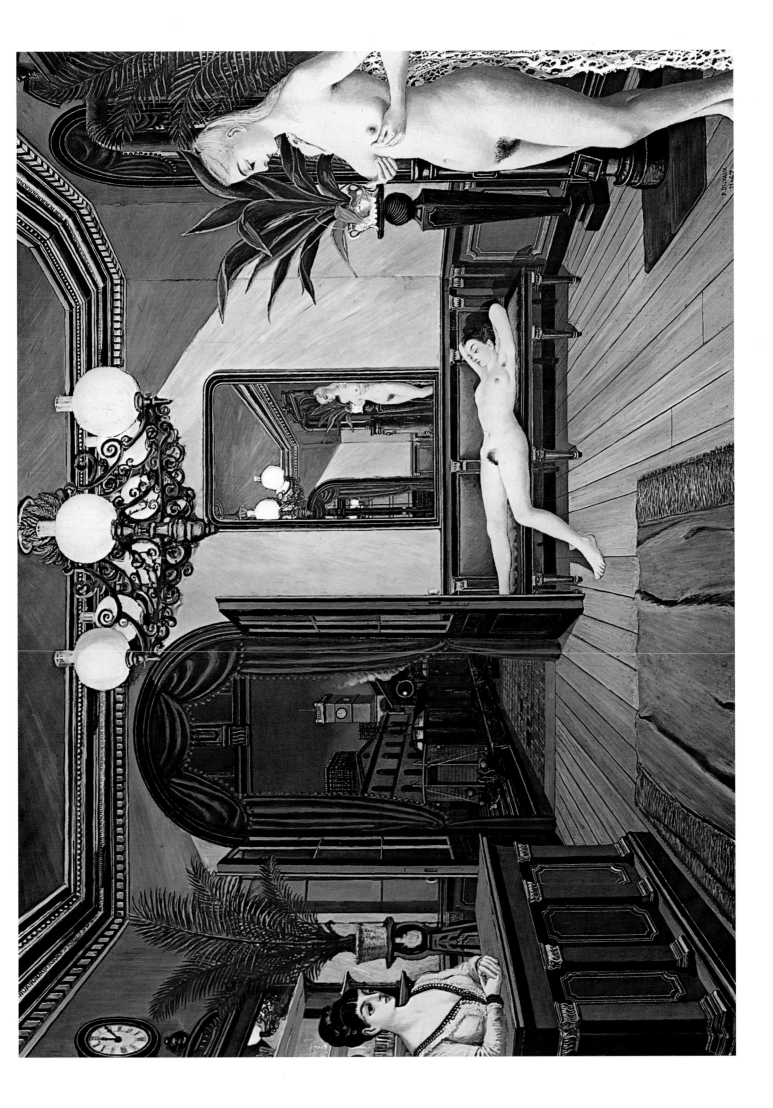

PAUL DELVAUX (b. 1897)

Sleeping Venus

Oil on canvas, 173 x 199 cm. 1944. London, Tate Gallery

Delvaux visited Italy in 1938 and again in 1939 and was impressed by the architecture of ancient Rome. *Sleeping Venus* is an example of the classical architectural settings he then began to use in some of his paintings. As is often the case with Surrealist painters, Delvaux is reworking in a striking and original way one of the great traditional subjects of European art, Death and the Maiden. Delvaux's Venus lies in a receptive posture as the skeleton steps forward to embrace her. The imagery of death and the maiden has always operated as a particularly chilling *memento mori*, given an edge by its macabre eroticism, but it is also emblematic of the cycle of life.

There are other elements in this painting on which Delvaux has commented: 'It is my belief that, perhaps unconsciously, I have put into the subject of this picture a certain mysterious and intangible disquiet – the classical town, its temples lit by the moon, with, on the right, a strange building with horses' heads which I took from the old Royal Circus at Brussels, some figures in agitation with, in contrast, this calm sleeping Venus, watched over by a black dressmaker's dummy and a skeleton. I tried in this picture for contrast and mystery. It must be added that the psychology of the moment was very exceptional, full of drama and anguish.' Delvaux is here referring to the fact that *Sleeping Venus* was painted in Brussels in 1944 during the flying bomb attacks on the city and he adds: 'I wanted to express this anguish in the picture, contrasted with the calm of the Venus.'

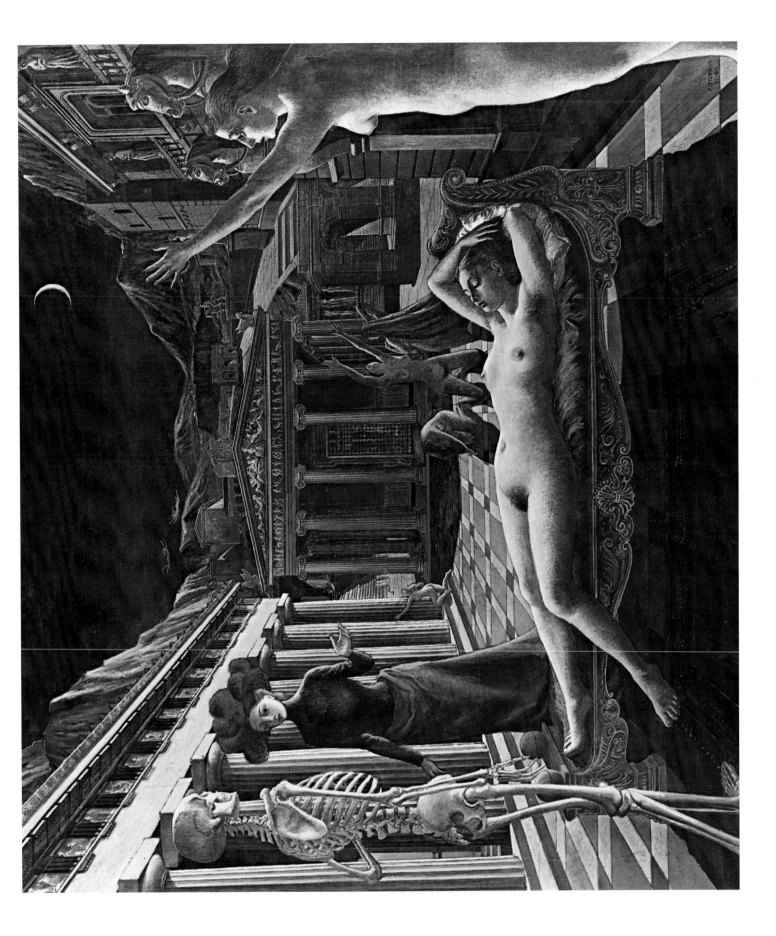

Mama, Papa is Wounded!

Oil on canvas, 92 x 73 cm. 1927. Collection, The Museum of Modern Art, New York. Purchase

Yves Tanguy has a special position among the Surrealist painters in that his painting represents a unique and highly successful synthesis of the two main branches of Surrealist painting, the automatic and the oneiric (see Introduction). Tanguy had no art training. He started a career in the merchant marines and was drafted into the army during the 1914-18 War. After the war he lived in Paris, doing odd jobs, and one day in 1923 saw a painting by de Chirico in the window of an art gallery as he was passing on a bus. It was after this that he decided to become an artist. He met the Surrealists soon after and indeed his house in the Rue du Chateau became an important meeting-place. *Mama, Papa is Wounded!* is one of Tanguy's earliest mature masterpieces. In it he combines the biomorphic imagery of Miró and Arp with the three-dimensional illusionism of the oneiric painters. The results are particularly effective and haunting 'landscapes of the mind'. The title of this work is powerfully emotive and according to the art historian James Thrall Soby was taken from a psychiatric case history. The extraordinary hairy phallic object on the right presumably represents the father, emitting, like some wounded marine creature, a grey cloud; the mother is perhaps the green figure and the infant the jumping-bean-like object in the centre.

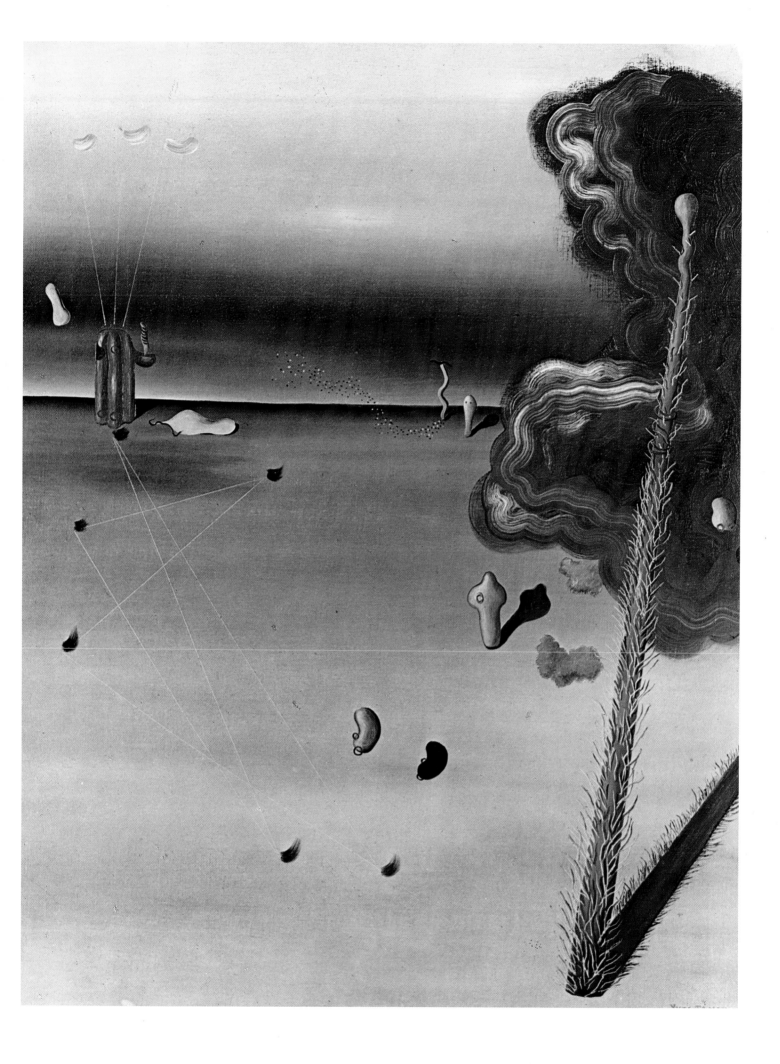

YVES TANGUY (1900-55)

Outside

Oil on canvas, 118 x 91 cm. 1929. Private Collection

It has frequently been pointed out that almost all Tanguy's works strongly suggest beach scenes or submarine landscapes. Equally, his biomorphic forms strongly suggest pieces of sculpture standing in the landscape. Tanguy spent his childhood summers at the family home at Locronan in the Finistère province of Brittany and Tanguy was evidently strongly affected by the environment there. According to James Thrall Soby, 'The fields near Locronan are peopled with menhirs and dolmens from prehistoric times and these, subjectively transformed, are frequent properties in the dream world Tanguy celebrated as an adult painter. Moreover, he never forgot the vast plateaux of the Brittany midland nor the submarine landscape of its rocky shore, where objects float hesitantly in the underwater light, shifting with the depth and tide' (James Thrall Soby, *Yves Tanguy*, New York, 1955). *Outside* is a particularly beautiful and quite enigmatic example of Tanguy's early manner.

The Ribbon of Extremes

Oil on canvas, 35 x 45 cm. 1932. Private Collection

A slight shift takes place in the character of Tanguy's painting in the early 1930s. The light becomes brighter, clearer and harder, the forms more sharply defined and above all more numerous. The colours, as in this case, are often extremely beautiful. Here the suggestion is almost of a procession or Bacchanal of biomorphs along a beach, although ultimately the scene remains completely undefinable. André Breton wrote of Tanguy's paintings of this kind: 'The tide ebbs, revealing an endless shore where hitherto unknown composite shapes creep, rear up, straddle the sand, sometimes sinking below the surface or soaring into the sky. They have no immediate equivalent in nature and it must be said that they have not as yet given rise to any valid interpretation.'

SALVADOR DALI (1904-1989)

The Persistence of Memory

Oil on canvas, 24 x 33 cm. 1931. Collection, The Museum of Modern Art, New York. Given anonymously

The predominantly sexual, heavily Freudian imagery of Dali's earliest Surrealist paintings (see Fig. 6) gave way in the early 1930s to wider thematic preoccupations and throughout the decade he produced a sequence of extraordinary masterpieces, some of the greatest of which are reproduced in Plates 27-31. Among the earliest of these, and probably the most celebrated of all Dali's paintings, is *The Persistence of Memory*. In a haunted, empty landscape are three soft watches, one of them draped over a melting human head which appears to be a portrait of Dali himself. The theme of this truly bizarre and mysterious painting is man's profound obsession with the nature of time and Dali expresses too the anguish of our awareness of the limitations of time on our own existence. The evocation of softness is one of Dali's most brilliant and compelling inventions: his soft objects are powerful and disturbing images of entropy – that fundamental physical process by which all things decay in time.

Lobster Telephone (Fig. 26) is one of Dali's best-known Surrealist objects (see Introduction). It was made for the English collector Edward James and was installed in his London house together with the celebrated sofa designed by Dali in the shape of Mae West's lips. Dali is fascinated by certain insects and marine crustacea, which appear to have strong sado-erotic connotations for him. Here the user speaks into the tail or sexual part of the lobster while simultaneously being menaced about the head by its claws.

Fig. 26
SALVADOR DALI
Lobster Telephone

Mixed media, 18 x 33
x 18 cm. 1936. London,
Tate Gallery

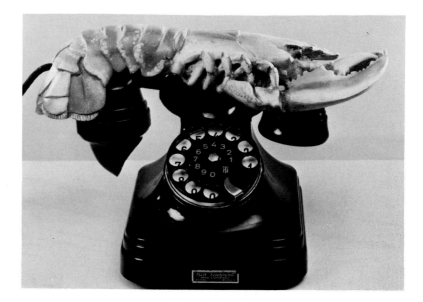

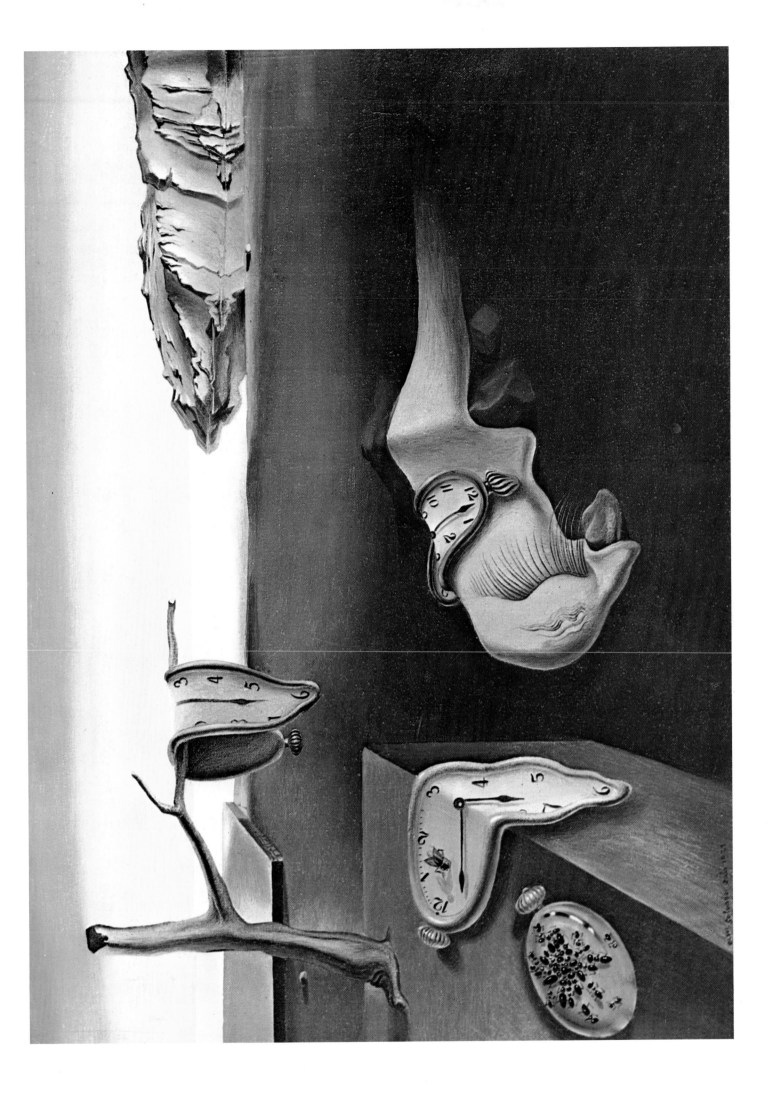

Sleep

Oil on canvas, 50 x 77 cm. 1937. Private Collection

Almost as celebrated as *The Persistence of Memory*, this is a strikingly original depiction of a state which, as we have seen (see Introduction), was of great concern to the Surrealists. Dali's use of crutches in his paintings has always aroused great curiosity. In his autobiography *The Secret Life of Salvador Dali* he wrote: 'My symbol of the crutch so adequately fitted and continues to fit into the unconscious myths of our time that, far from tiring us, this fetish has come to please everyone more and more. And, curiously enough, the more crutches I put everywhere so that one would have thought people had at last become bored by or immune to this object, the more everybody wondered with whetted curiosity "Why so many crutches?"' Dali makes it clear that the general symbolism of the crutches is social and political when in *The Secret Life* he satirically describes his introduction into fashionable Paris society on his arrival from Spain in 1929: 'I decided to join forces with the groups of invalids whose snobbism propped up a decadent aristocracy which still stuck to its traditional attitudes. But I had the idea of not coming empty handed like all the rest. I arrived, in fact, with my arms loaded with crutches! One thing I realized immediately. It would take quantities and quantities of crutches to give a semblance of solidity to all that.'

In the case of *Sleep* the crutches, Dali says, have a more specific role: 'I have often imagined the monster of sleep as a heavy, giant head with a tapering body held up by the crutches of reality. When the crutches break we have the sensation of "falling".' This sensation, common just at the moment of going to sleep, Dali suggests is a memory of the expulsion from the womb at birth. He has also referred to *Sleep* as '[a] painting in which I express with maximum intensity the anguish induced by empty space'.

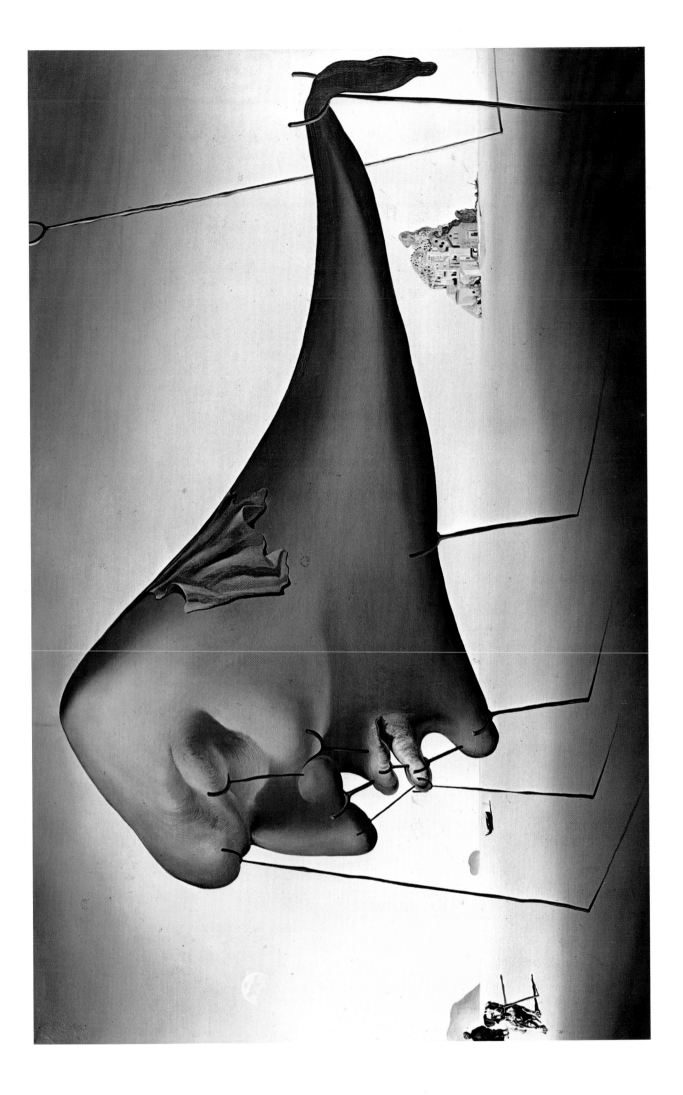

Soft Construction with Boiled Beans: Premonition of Civil War

Oil on canvas, 99 x 99 cm. 1936. Philadelphia Museum of Art, The Louise and Walter Arensberg Collection

Soft Construction, Mountain Lake (Fig. 27) and *Autumn Cannibalism* (Plate 30) are all works by Dali in which major contemporary political events are reflected in and blend with Dali's other obsessions to produce images of great complexity and power. *Soft Construction* in particular, apparently painted just before the outbreak of the Spanish Civil War in July 1936, must stand as one of the most original and compelling images of war made by any artist since Dali's great Spanish predecessor Goya. Indeed, the influence of Goya's etchings *The Disasters of War* (1803-13) is apparent in the Dali. The artist wrote of *Soft Construction:* 'I showed a vast human body breaking out into monstrous excrescences of arms and legs tearing at one another in a delirium of auto-strangulation.'

The telephone in *Mountain Lake* refers, according to Dali, to the calls which the British Prime Minister Neville Chamberlain made to Adolph Hitler in 1938 at the time of the Munich crisis. The fact of the telephone-line being cut off makes an obvious comment on the ultimate outcome of Chamberlain's calls. *Mountain Lake* is one of a group of similar works (chief among them *The Enigma of Hitler*) which, Dali wrote, 'constituted a condensed reportage of a series of dreams obviously occasioned by the events of Munich. This picture appeared to me to be charged with prophetic value, as announcing the medieval period which was going to spread its shadow over Europe.' *Mountain Lake* does indeed have an absolutely deathly atmosphere: the only sign of life is the two snails leaving their trail of slime. The lake itself is a very good example of one of Dali's personal pictorial devices, the so called 'paranoiac image', that is, an image that can be read as more than one thing. In this case the lake is also a fish on a table-top and, further, a large phallus.

Fig. 27
SALVADOR DALI
Mountain Lake

Oil on canvas, 73 x 92 cm.
1938. London, Tate
Gallery

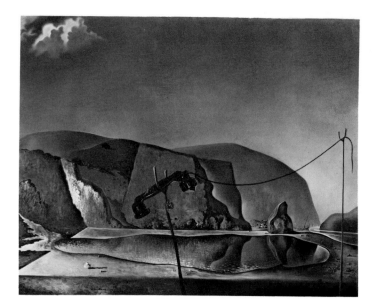

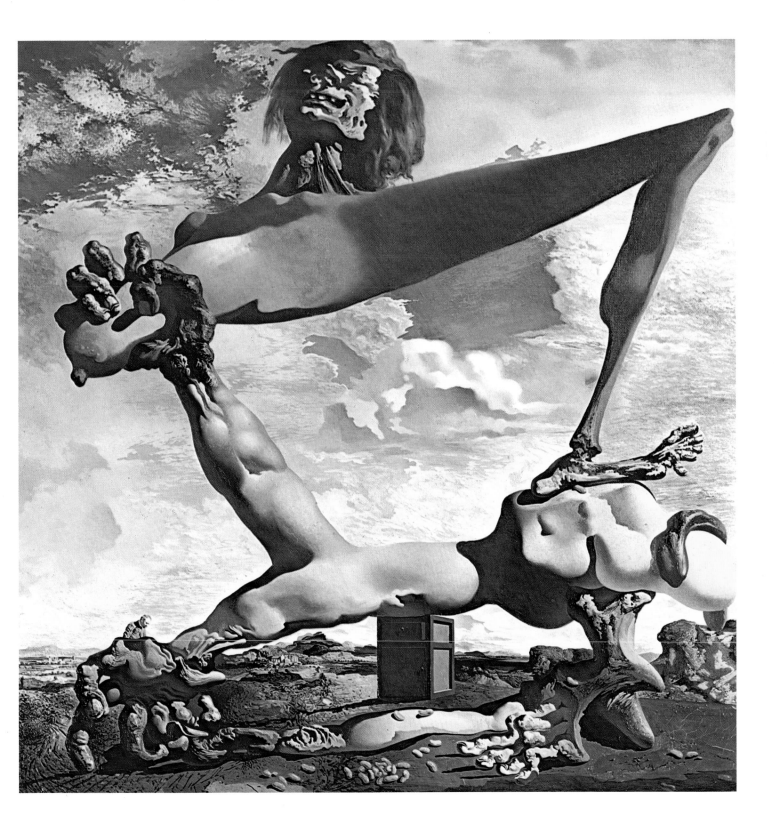

Autumn Cannibalism

Oil on canvas, 65 x 65 cm. 1936. London, Tate Gallery

This painting seems to have been done not long after *Soft Construction with Boiled Beans: Premonition of Civil War* (Plate 29) and can be seen as a companion to it. Dali said of *Autumn Cannibalism:* 'These Iberian creatures, devouring each other in autumn, symbolize the pathos of civil war seen as a phenomenon of natural history.' They do indeed constitute a powerful visual metaphor for the idea of a nation divided violently against itself. It has been convincingly suggested, too, that the image of the self-devouring couple has its roots in Dali's own sexual life, specifically his first physical contact with Gala Éluard, who later became his wife and muse. Dali describes this episode in *The Secret Life:* 'And this first kiss, mixed with tears and saliva, punctuated by the audible contact of our teeth and furiously working tongues, touched only the fringe of the libidinous famine that made us bite and eat everything to the last.' The image can also be read as a straightforward comment on the relations between men and women. With its many potential layers of meaning this work is typical of the richness and complexity achieved by Dali during this great period.

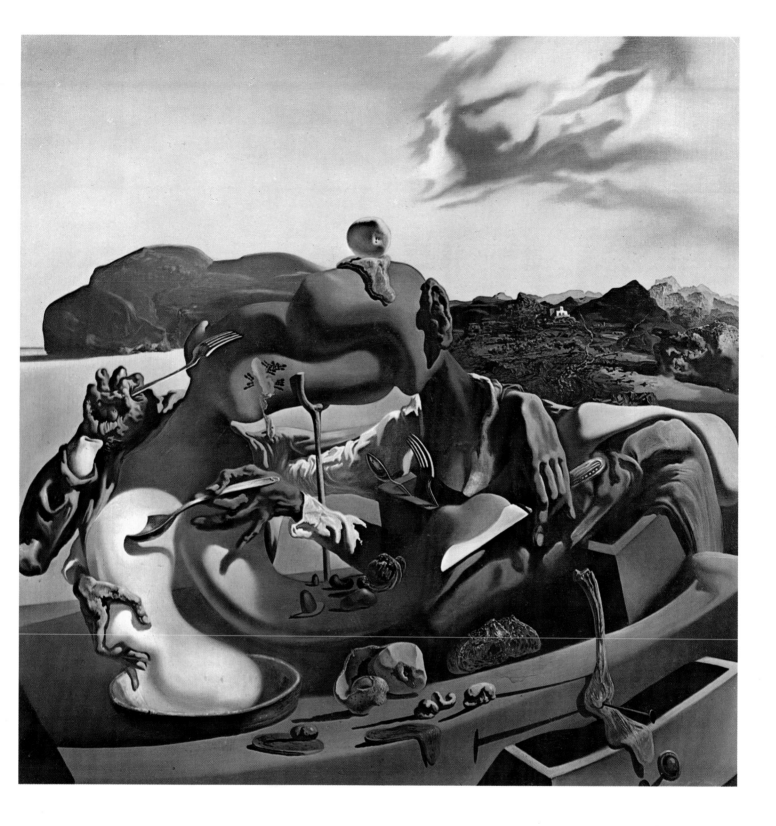

The Metamorphosis of Narcissus

Oil on canvas, 51 x 78 cm. 1938. London, Tate Gallery

As a Surrealist reworking of one of the most potent ancient Greek myths this painting represents yet another aspect of the richness and range of Dali's work in the 1930s. It is particularly interesting since it enables us to glimpse something of the workings of Dali's 'Paranoiac-Critical' method (see Introduction). Shortly after its completion Dali published a book of the same title, consisting largely of a long poem prefaced by the announcement: 'THE FIRST POEM AND THE FIRST PICTURE OBTAINED ENTIRELY THROUGH THE INTEGRAL APPLICATION OF THE PARANOIAC-CRITICAL METHOD'. From the subsequent text it can be inferred that the painting had its origins in a snatch of conversation between two fishermen which Dali overheard at Port-Lligat (the small fishing-village in Catalonia that has been his home since 1930). They are evidently speaking of a slightly demented villager:

First Fisherman: What's the matter with that chap staring at himself in a mirror all day?

Second Fisherman: If you really want to know he's got a bulb in his head.

The dialogue seems to have set up in Dali a dynamic chain of associations of the kind characteristic of paranoiac thought: the mention of the mirror evoked the myth of Narcissus; the vivid Catalan phrase for mental imbalance 'to have a bulb in the head' gave rise to the idea of a flower sprouting from the body's head. To this Dali added the equally original concept of the body metamorphosing into a hand. In sum Dali created a completely new and deeply compelling iconography for this old story. In the painting we first see the live Narcissus posing on a pedestal in the background. Then we see him kneeling in the fatal pool, and finally on the bank of the pool in the form of a fossilized hand holding the egg from which the Narcissus flower now blooms. By a masterly stroke of illusionism, a virtuoso piece of painting, Dali makes the transformation take place before our eyes as we look from one of the two main figures to the other. On one level this painting deals with the important psychological element of self-love or narcissism, but beyond that it is, like the original myth, an expression of the cycle of life.

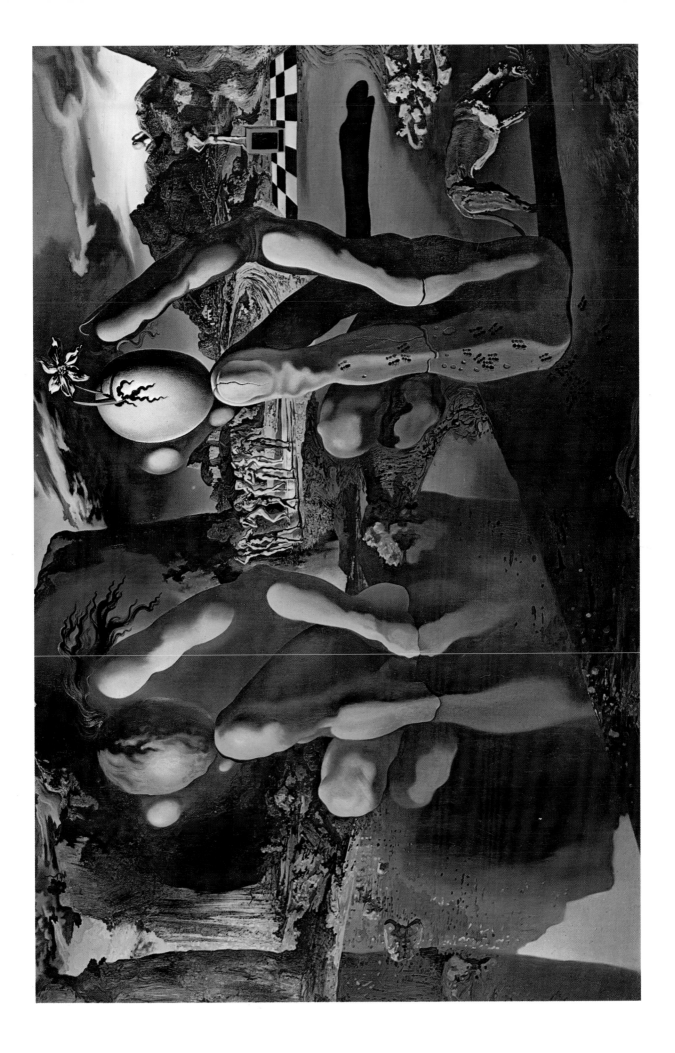

PIERRE ROY (1880-1950)

Danger on the Stairs

Oil on canvas, 91 x 60 cm. 1927-8. Collection, The Museum of Modern Art, New York.
Gift of Abby Aldrich Rockefeller

Pierre Roy was a French painter who seems to have been something of a
natural Surrealist. In 1919 he met de Chirico, and it was at about that
time that he started painting his first characteristic works. De Chirico
introduced him to Breton and the other Surrealists and Roy subsequently
participated in the first exhibition of Surrealist painting at the Galerie
Pierre in 1925. His work is strongly dreamlike in atmosphere and in spite
of a strong superficial resemblance to that of Magritte, it is entirely per-
sonal. *Danger on the Stairs* is a highly successful example of the Surrealist
strategy of transforming the familiar everyday world to express subcon-
scious fears or fantasies. Here the scene is basically banal: the stairway of
a typical French apartment building. But there is a mystery about the
closed doors and the way the staircase extends beyond the confines of
the picture; the disruption of everyday reality is completed by the
presence of the snake, a creature of which man's fear and hatred is
deep-rooted, irrational and, according to recent research, perhaps even
instinctual.

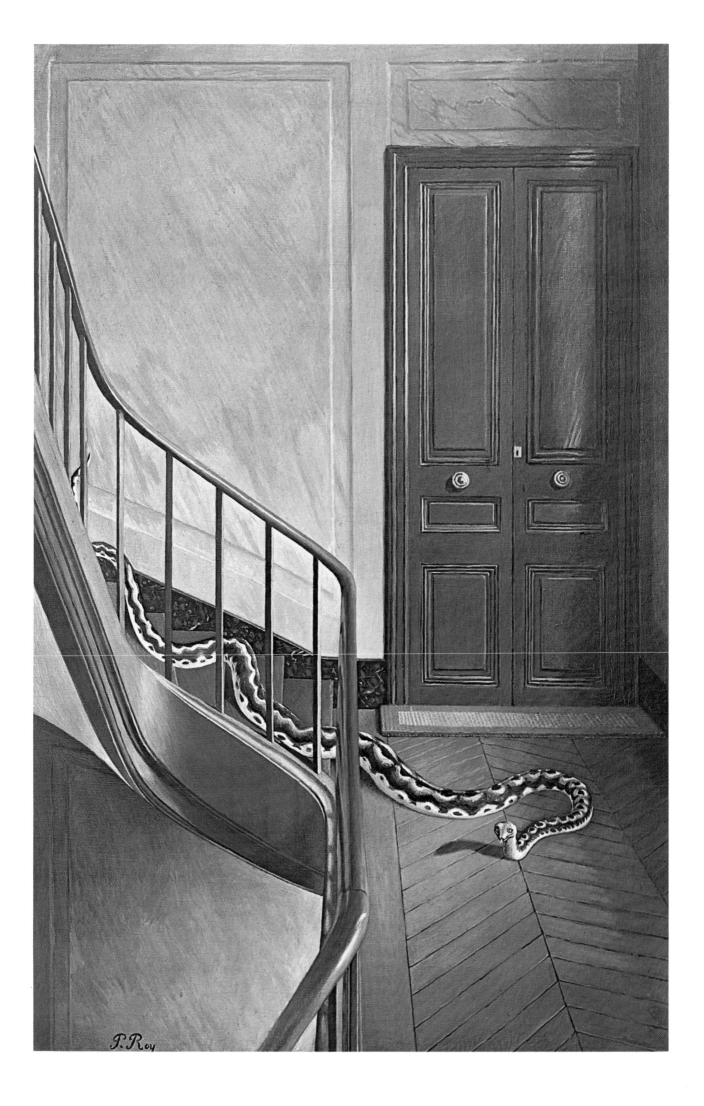

PIERRE ROY (1880-1950)

A Naturalist's Study

Oil on canvas, 92 x 65.5 cm. 1928. London, Tate Gallery

According to the artist's son, who has written illuminatingly of this enigmatic work, it was painted at a time when his father 'was prey to a deep nervous and above all emotional depression. Barely recovered from the death of my mother, feeling a certain responsibility for her death, terrified by the thought of having a nine-year-old son and being ill-prepared for this responsibility, which he felt, wrongly as it turned out, would be a thorn in his side, abandoned by his mistress of the moment, nothing was going right for him, neither morally, nor emotionally, nor physically nor financially above all. That is why this strange picture if it is examined very clearly gives an impression of uncertainty in its precision and stillness, with movement only perceptible in the background of the painting. In fact the wheel, which I possess, is single instead of double, the hub cannot function as it has no hole through it, the paper snake is fastened to the floor, the string of eggs gives no suggestion of life, and as for the locomotive the wheels of the tender are coupled together, the steam from the whistle rises in the reverse direction to the smoke from the chimney and is lost in a menacing and static storm cloud. It is very hot and the trees dare not budge, as if they feared by their movement to disturb the intense heaviness of the whole. Life seems to have stopped and become fixed like the locomotive itself in front of a chance or imaginary obstacle.' This is a vivid evocation of the way in which the elements in a Surrealist painting can be emblematic of a state of mind. (Letter from the artist's son quoted by Ronald Alley in *The Catalogue of the Tate Gallery's Collection of Modern Art other than Works by British Artists*, 1981)

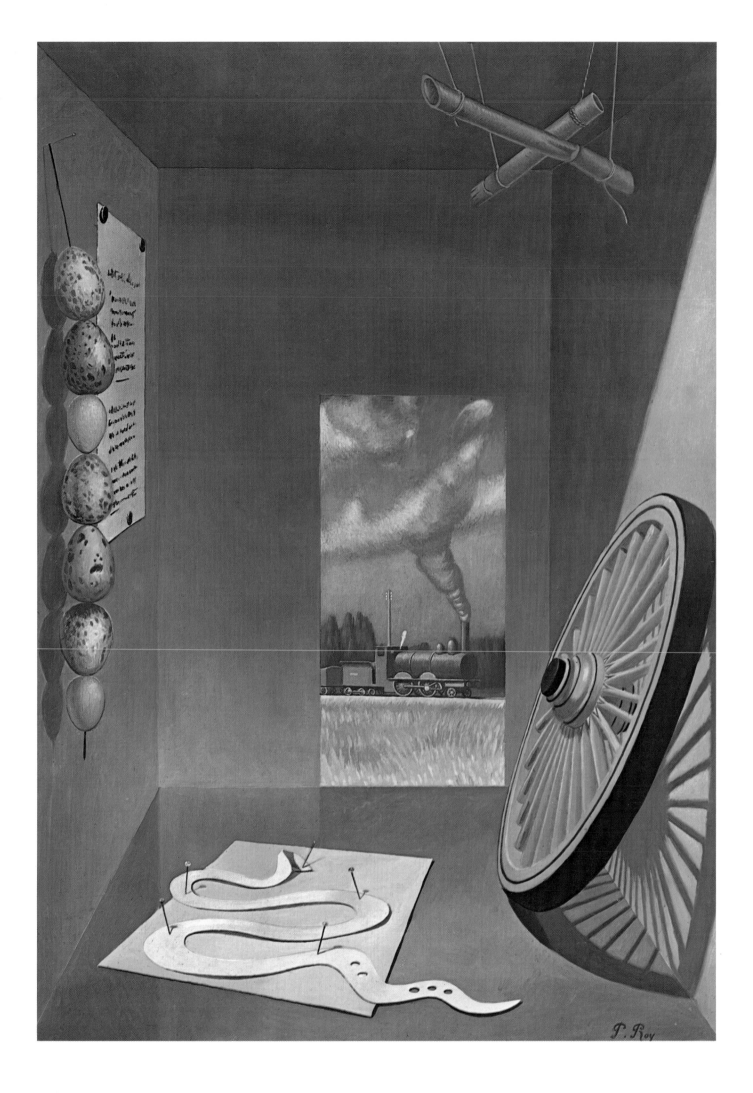

The Robing of the Bride

Oil on canvas, 130 x 96 cm. 1940. Venice, Peggy Guggenheim Collection
(The Solomon R. Guggenheim Collection)

Around 1940 Ernst returned in some paintings to a modified version of the oneiric manner of his first great Surrealist paintings (Plates 1-3) and *The Robing of the Bride* is a masterpiece of this phase. Like Magritte's *Pleasure* (Plate 16) it appears to be a Surrealist rendering of that significant subject, the loss of virginity. The amazing feathered cloak reveals again Ernst's obsession with birds, and the critic Robert Melville has suggested that it may have been inspired by the Peruvian ritual mantle of feathers which was in Ernst's own collection. Melville also points out how evocative this cloak is of the passage in Breton's essay *Beauty Will Be Convulsive:* 'In another grotto, the Fairy Grotto near Montpellier, where you walk round between walls of quartz, the heart stands still for several seconds at the spectacle of a gigantic mineral cape, called 'The Emperor's Mantle', whose drapery forever defies that of statuary and which a spotlight covers with roses, as though determined that it should be in no way inferior to that other and none the less splendid and convulsive mantle made of the infinite repetition of the unique little red feathers of a rare bird, which is worn by Hawaiian chieftains.'

After his first love affair with frottage Ernst continued to exploit the possibilities of collage, producing in particular a number of collage 'novels' – whole books in collage. *Yachting* (Fig. 28) is from one of these, *La Femme 100 têtes* (thst is 'sans tête') of 1929. This title is a complicated play on words: it can be translated as either *The Hundred-Headed Woman* or *The Woman without a Head* and seems to relate to a recurring obsession that can also be seen in the headless woman in *Celebes* (Plate 1).

Fig. 28
MAX ERNST
Yachting

Collaged engraving from
'La Femme 100 têtes'
(Editions du Carrefour,
1926), 8 x 11 cm. 1929.
Private Collection

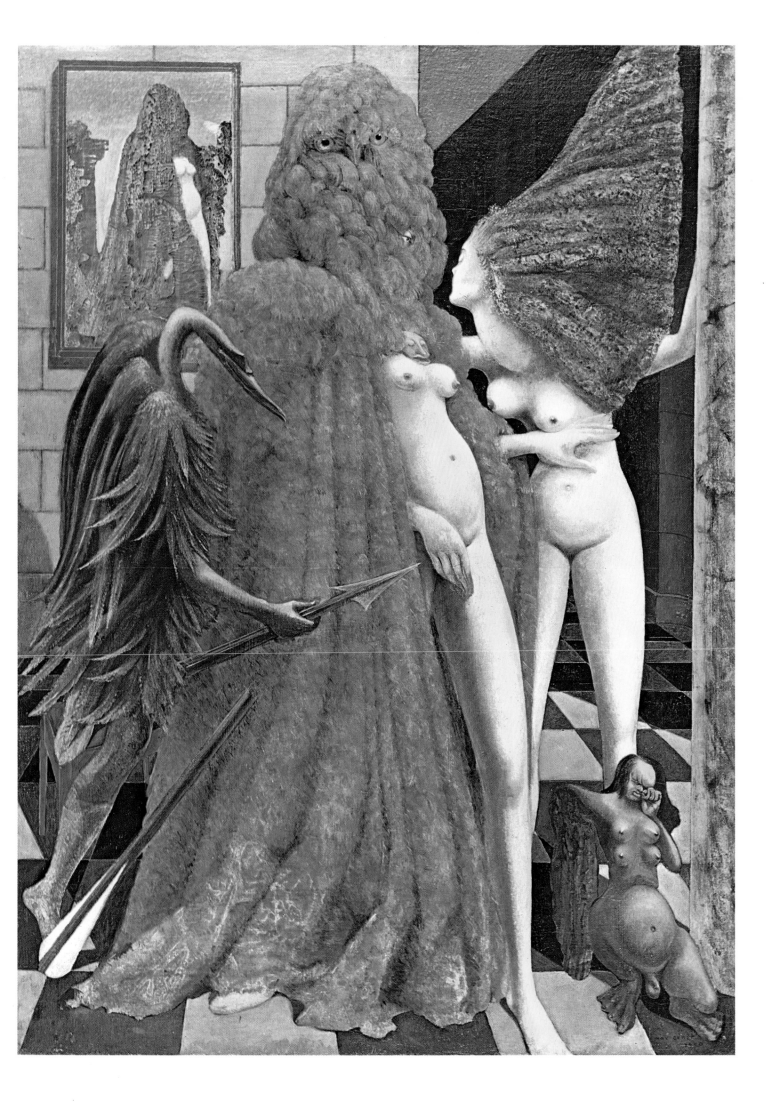

LEONOR FINI (b. 1908)

Figures on a Terrace

Oil on canvas, 99 x 79 cm. 1938. Edward James Foundation

Leonor Fini was born in Buenos Aires and was brought up in Trieste in a literary and intellectual family circle that included James Joyce. She left home at seventeen and went to Paris where she met Max Ernst and Paul Éluard and began to teach herself to paint. *Figures on a Terrace* is an early example of her vision of an erotic dream-world inhabited by beautiful, exotic and decadent young people. 'All my painting', she has written, 'is an incantatory autobiography of affirmation, the will to express the radiant aspect of being . . . ' In his *Letter to Leonor Fini* published in 1950 Jean Genet wrote: 'Would I love an art so much if I had not discovered in it, and from its very beginnings, not that which I ultimately seek – and which will belong exclusively to me – but those same despairing elements scattered across sumptuous cemeteries.'

DOROTHEA TANNING (b. 1910)

'Eine Kleine Nachtmusik'

Oil on canvas, 41 x 61 cm. 1946. Private Collection

Dorothea Tanning, the American Surrealist painter and sculptor, was born at Galesburg near Chicago. Self-taught, she moved to New York in 1935 and in 1936 was deeply impressed by the great exhibition *Fantastic Art, Dada, Surrealism* at the Museum of Modern Art. In 1942 she met Max Ernst and married him four years later; through him she came into contact with the rest of the Surrealists then living in New York (see Introduction). *Eine Kleine Nachtmusik* is characteristic of her painting of that time, depicting a world seemingly inspired by childhood fantasies and nightmares. It has in particular a feeling of *Alice Through the Looking Glass*, one of the Surrealists' favourite literary works of the past. She and Ernst lived for some years in Arizona and then in 1950 moved to France. Since the mid-1950s Tanning's painting has become 'automatic' in character, the imagery of her earlier work becoming obscure, wrapped in veils of mist.

MAN RAY (1890-1976)

Pisces

Oil on canvas, 65 x 73 cm. 1938. London, Tate Gallery

Man Ray was born in Philadelphia, U.S.A. He met Marcel Duchamp in New York in 1915 and together they created what became the New York Dada Group. In 1921 Man Ray moved to Paris, where he met Breton and subsequently participated in the Surrealist movement. He is best known as a photographer but he was also a pioneer of Dada/Surrealist object-making and a painter.

Pisces is based on a drawing made in 1936 called *La Femme et son Poisson* ('The Woman and her Fish'). The drawing was one of a group Man Ray showed to the Surrealist poet Paul Éluard, who subsequently wrote a short poem about each one. The drawings and poems were published in 1937 in Paris as *Les Mains Libres*. Man Ray has written of *Pisces:* 'There is no hidden theme to the painting. It is a contrasting of similar and different forms at the same time; in this case aerodynamic.' It may be added, however, that the painting, like much of Man Ray's work, has a strongly erotic character and that it is also an outstanding example of the Surrealist fascination with metamorphosis.

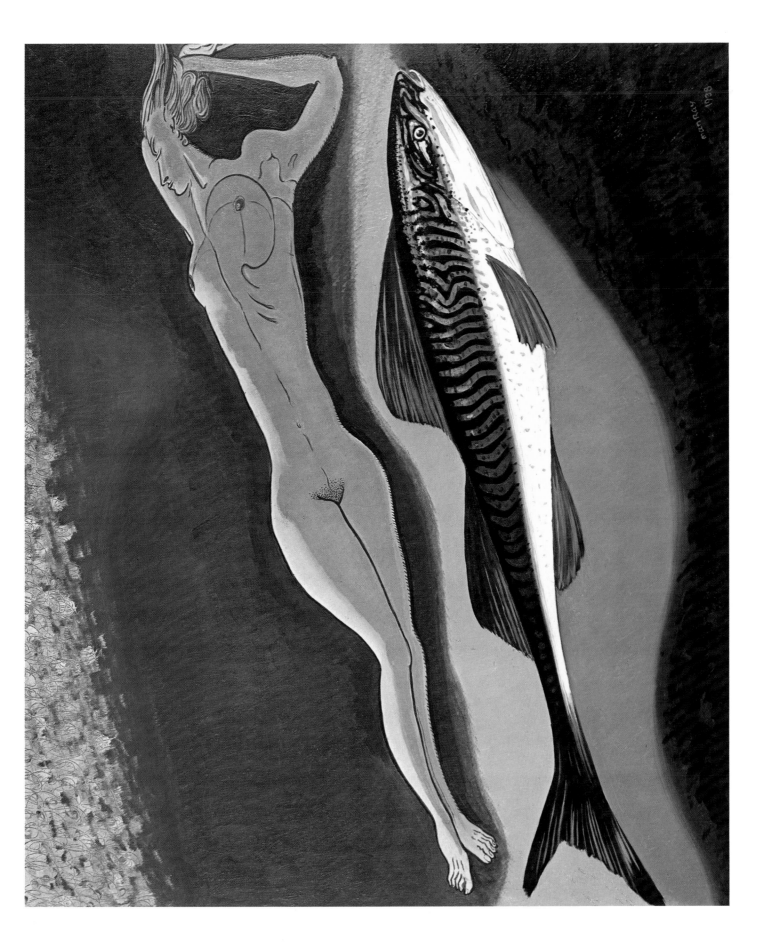

HANS BELLMER (1902-1975)

Peg-top

Oil on canvas, 65 x 65 cm. c.1937-52. London, Tate Gallery

The German-born Surrealist Hans Bellmer trained first as an engineer, but in 1924 he met George Grosz and Otto Dix, two of the dominating figures in German art of the period, and this encounter seems to have confirmed both his vocation as an artist and the direction of his art: like Grosz and Dix his vision of humanity is essentially tragic and pessimistic. 'If my art is scandalous it is because the world is a scandal' he once remarked to a critic. The basis of Bellmer's whole *oeuvre* is the doll, now one of the most celebrated of Surrealist objects. It came into being around 1933, as a result of Bellmer's impossible love for his adolescent cousin Ursula. Finally he decided, 'I shall construct an artificial girl whose anatomy will make it possible physically to recreate the dizzy heights of passion and to do so to the extent of inventing new desires.' Bellmer, a gifted photographer, recorded various poses of the doll and sent them to the Surrealist review *Minotaure* in Paris. They were received with acclaim in Surrealist circles and were published immediately. It is through Bellmer's marvellous, often beautifully hand-tinted photographs that the doll can best be appreciated (Fig. 29) since they reveal the full imaginative potential of Bellmer's invention. (The original is now in the Musée National d'Art Moderne in Paris.) Bellmer continued throughout his life to explore the possibilities of the bizarre anatomical combinations and metamorphoses originally suggested by his manipulations of the doll; he produced mainly drawings and engravings but also a few paintings such as *Peg-top*, an authentically convulsive composite of male and female sexual anatomy.

Fig. 29
HANS BELLMER
The Doll

Photograph tinted with coloured ink, 53 x 53 cm. c.1936. London, Tate Gallery

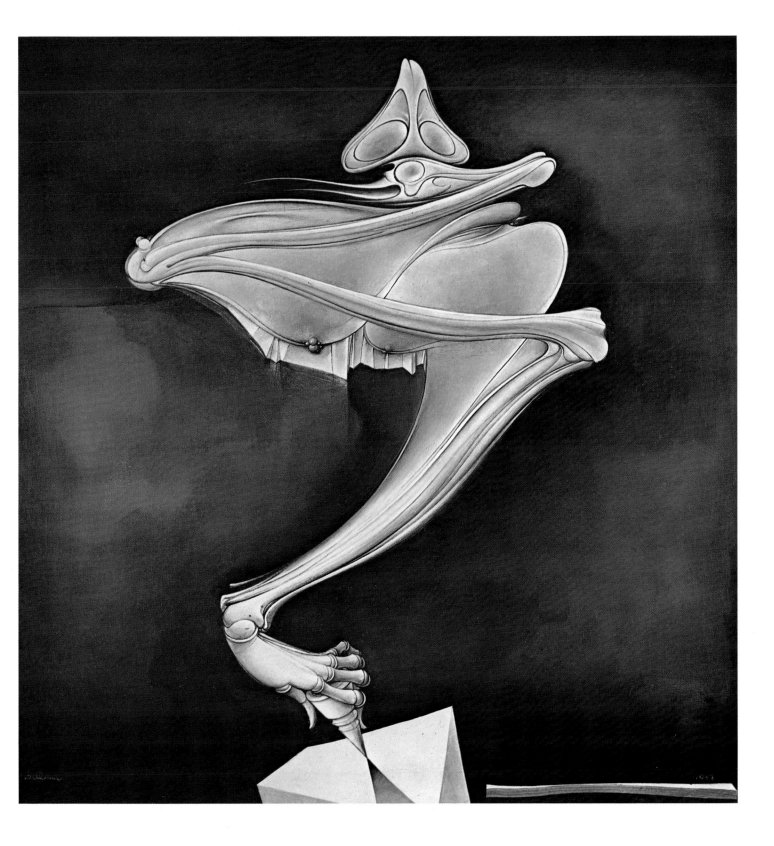

BALTHUS (b. 1908)

Sleeping Girl

Oil on millboard, 79.5 x 98.5 cm. 1943. London, Tate Gallery

Known always simply as Balthus, Balthasar Klossowski de Rola was born in Paris in 1908. His parents were both painters and his father also wrote on art. Friends of the household during Balthus' youth included the painters Bonnard and Derain. He taught himself to paint by copying the old masters in the Louvre and in Italy. He had his first one-man exhibition in 1934 at the Galerie Pierre in Paris, which had been the venue for the first exhibition of Surrealist painting in 1925. Balthus was never a member of the Surrealist group but his work, in which a fine traditional technique is used to create a disturbing and dreamlike image of the world, clearly held a strong appeal for the Surrealist sensibility. In particular his paintings of young girls, asleep or lost in daytime reverie, and the undoubted eroticism of the atmosphere of those pictures seems to give him a prominent place in the oneiric tradition of Surrealist painting.

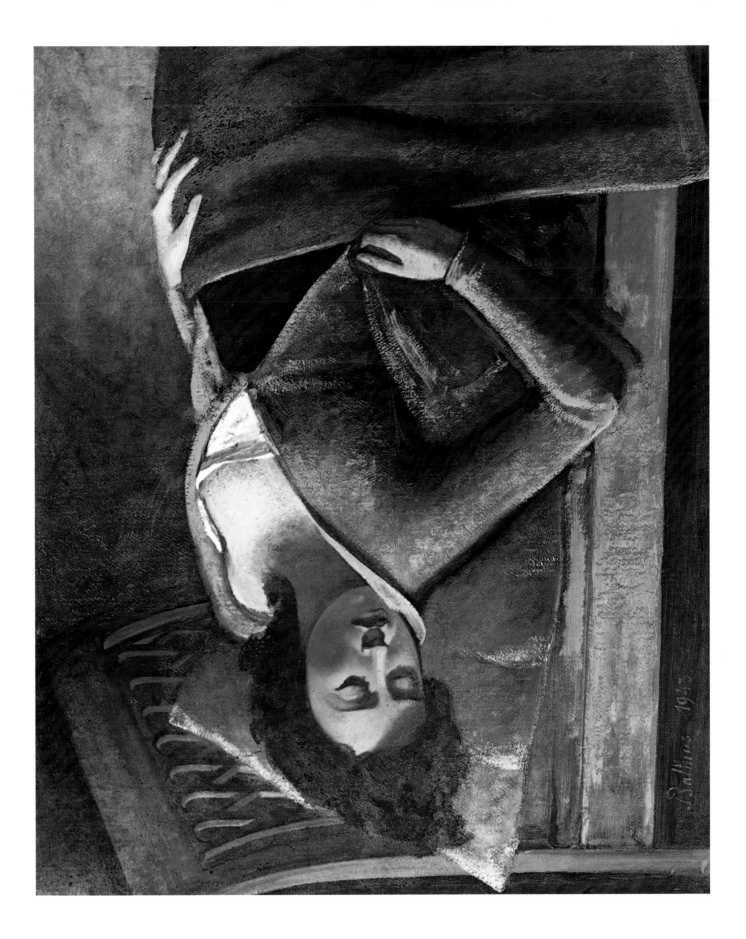

Girl and Cat

Oil on panel, 87 x 78 cm. 1937. Private Collection

On the occasion of Balthus' first exhibition in 1934 the Surrealist actor and playwright Antonin Artaud wrote enthusiastically of the poetry that enters Balthus' painting 'where the body of a young girl in love imposes itself in dreamlike fashion on a canvas that has the realism of Courbet's *Atelier*.' The sphinx-like cat appears in many of Balthus' pictures of this kind and according to the critic John Russell, Balthus painted a self-portrait in 1937 which he inscribed 'The King of the Cats'.

Balthus was appointed Director of the French Academy in Rome in 1961 and held this post until 1967. The renewed vigour of his later painting has been apparent in recent exhibitions, and he remains one of the greatest modern masters of the European figure-painting tradition.

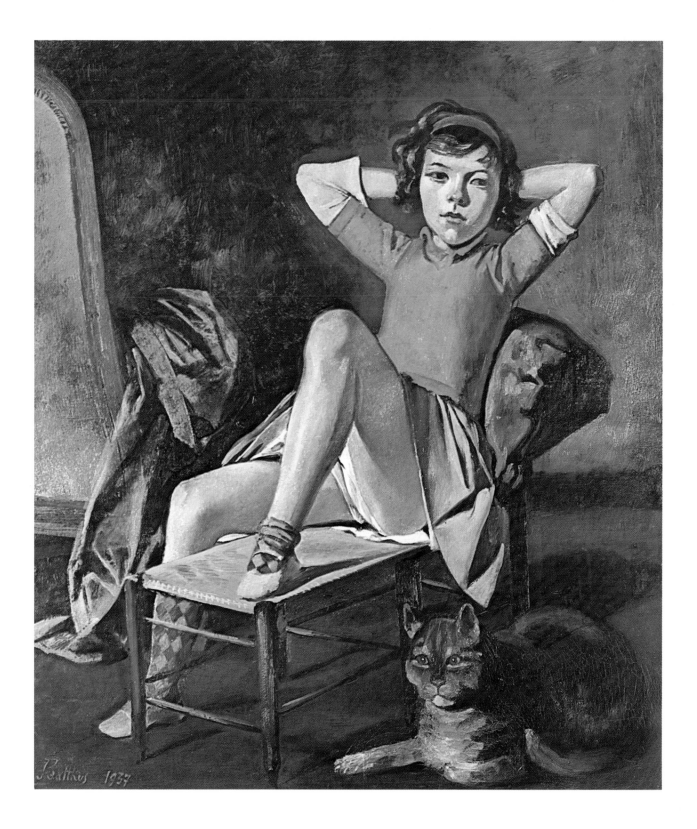

Landscape from a Dream

Oil on canvas, 68 x 102 cm. 1936-8. London, Tate Gallery

Fig. 30
PAUL NASH
Swanage

Collage, 40 x 58 cm.
c.1936. London, Tate
Gallery

Paul Nash was one of the organizers of and leading contributors to the 1936 International Surrealist Exhibition in London. His art had always had a visionary and imaginative character and it is not surprising that he responded strongly to the stimulus of Surrealism in the early 1930s. As he put it, 'I did not find Surrealism, Surrealism found me.' *Landscape from a Dream* and *Harbour and Room* (Fig. 11) are certainly among the leading examples of English Surrealist painting. *Landscape from a Dream* and the collage *Swanage* (Fig. 30) were both inspired by the environment of Swanage on the Dorset coast where Nash lived from autumn 1934 to spring 1936. Swanage had a special significance for Nash (as certain places often did for Surrealists) and in 1936 he published an article entitled 'Swanage or Seaside Surrealism' in the *Architectural Review*. 'It's just a Surrealist dream', he wrote, ' . . . a dream image where things are so often incongruous and slightly frightening in their relation to time and place.' Nash took strongly to the technique of collage and often, as in *Swanage*, used his own photographs as material; he also had to a very special degree the Surrealist sensitivity to the mysterious properties that found objects can possess. The strange elements in *Swanage* are all *objets trouvés*. The one in the sky at the top left (a piece of furzewood) Nash named *Long-gompa* after the priests in Tibet who are reputed to be able to cover huge distances in a trance-like state.

Eileen Agar was selected by Herbert Read and Roland Penrose for the 1936 London Surrealist Exhibition: 'Both of us were at once enchanted by the rare quality of her talent, the product of a highly sensitive imagination and feminine clairvoyance.' Agar shares with Nash a sensitivity to found objects and to the marine environment, and she made particular use of the techniques of collage and assemblage (Fig. 31). Her images, Herbert Read wrote, ' . . . are the flora and fauna of a desert island, which somehow have escaped the normal course of evolution, and though they vaguely remind us of familiar flowers and animals it is only to mock our solemn realism.'

Fig. 31
EILEEN AGAR
Fish Circus

Mixed media,
18.5 x 24 cm. 1936.
Private Collection

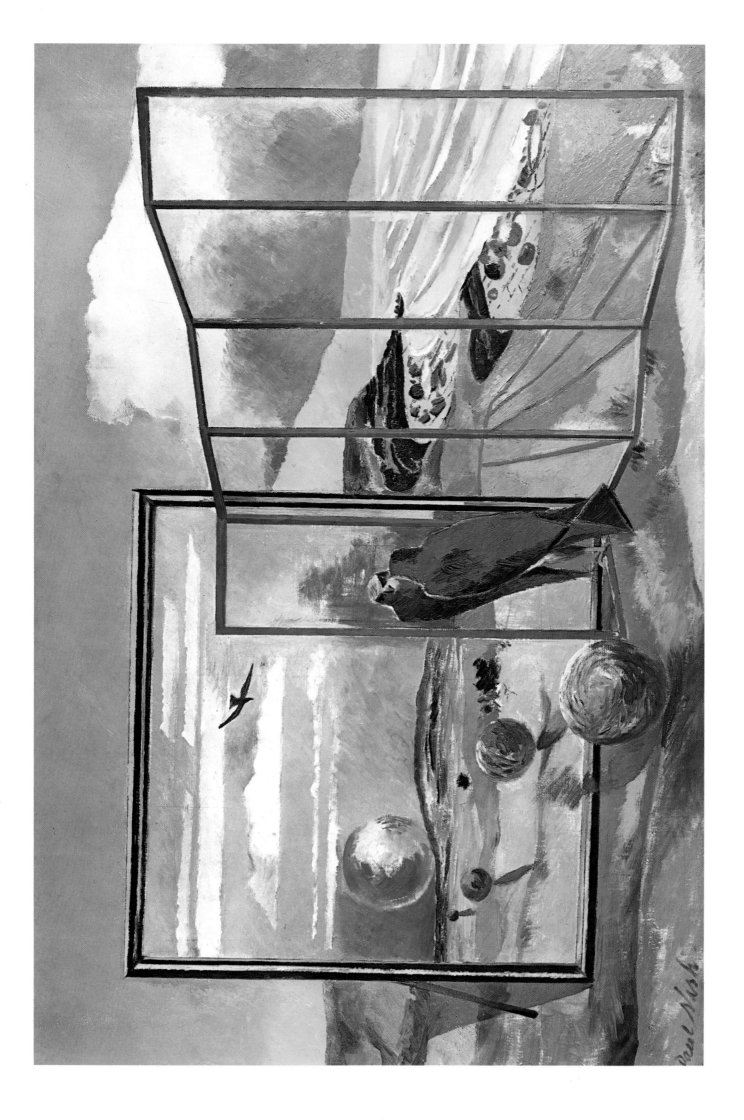

Winged Domino (Portrait of Valentine)

Oil on canvas, 60 x 44 cm. 1937. Private Collection

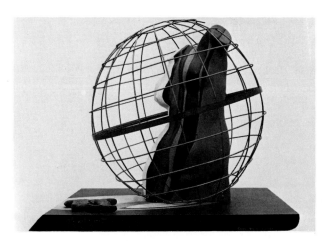

Fig. 32
ROLAND PENROSE
Captain Cook's
Last Voyage

Mixed media, 68.5 x 66 x
86.5 cm. 1936. Private
Collection

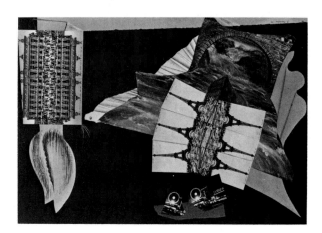

Fig. 33
ROLAND PENROSE
Magnetic Moths

Collage, 81 x 56 cm. 1938.
London, Tate Gallery

'Penrose est Surréaliste dans l'amitié' pronounced André Breton and it was through his friendships as well as his enthusiasm that the painter Roland Penrose brought Surrealism to England in 1936 when he organized the International Surrealist Exhibition in London. The painting *Winged Domino* was inspired by Penrose's first wife, the beautiful French poetess Valentine Boué, and it remains an intensely lyrical and romantic tribute to her, with its jewel-like butterflies feeding at her eyes and mouth as if on nectar.

Captain Cook's Last Voyage (Fig. 32) remains the masterpiece of English Surrealist object-making. From its combination of simple yet unexpected elements comes an image ultimately enigmatic yet richly suggestive of meanings. It evokes the Surrealist fascination with exotic and distant places and with the romance and nostalgia of travel. It places woman at the centre of the world – a very Surrealist attitude – and equates her with it: the bust in the globe becomes an earth-mother image with the painting of the body suggesting rivers and mountains. It suggests too the notion of a woman's body as a place for exciting explorations leading perhaps to hidden treasure. Cook's last voyage ended with his death in Hawaii, so Penrose has also evoked that association of death and the erotic which appears in so many Surrealist works.

Penrose made a particular contribution to the development of Surrealist collage with his system of composing new coloured images from pre-existing ones, mostly postcards. In *Magnetic Moths* (Fig. 33), a fine example of this technique, the Eiffel Tower by an extraordinary metamorphosis becomes the body of a moth.

CONROY MADDOX (b. 1912)

Passage de l'Opéra

Oil on canvas, 136 x 94 cm. 1940. London, Tate Gallery

Conroy Maddox made contact with the French Surrealists in 1937 and was exhibiting with the English group by 1940. Since then he has remained a consistent practitioner of the de Chirico tradition of Surrealist painting.

The Passage de l'Opéra, one of the old Paris arcades (most of which have now disappeared) was made famous by the Surrealist poet Louis Aragon, who described it in his book *Le Paysan de Paris* of 1924. Conroy Maddox has confirmed that his painting was certainly inspired by this book: 'Aragon points out that his wanderings around the Passage de l'Opéra were without purpose, yet he waited for something to happen, something strange or abnormal so as to permit him a glimpse of a "new order of things" . . . The picture was not painted until I returned to England, then entirely from memory. Certainly over a year after I had seen either the place or a photograph. It was not until the Cardinal and Short book *Surrealism, Permanent Revelation* was published in 1970 that I again saw a photograph of the passage and was able to check the accuracy of my memory. Apart from some architectural discrepancies, the lion in the foreground was certainly not present and obviously never had been in spite of my conviction that such a statue had existed near the entrance.'

The sense of frozen time and the mystery of the figures themselves, especially the anonymous one in the foreground, banal but sinister in his bowler hat, combine to convey the feeling that something abnormal is about to happen.

Maddox has always been an active collagist. Of *The Strange Country* (Fig. 34), an early example, he comments: 'I like the ready-made immediately recognizable elements for my collages . . . Each image is complete and recognizable but in the process of finding relationships the ordinary becomes extraordinary.'

Fig. 34
CONROY MADDOX
The Strange
Country

Collage, 41 x 28 cm. 1940.
London, Tate Gallery

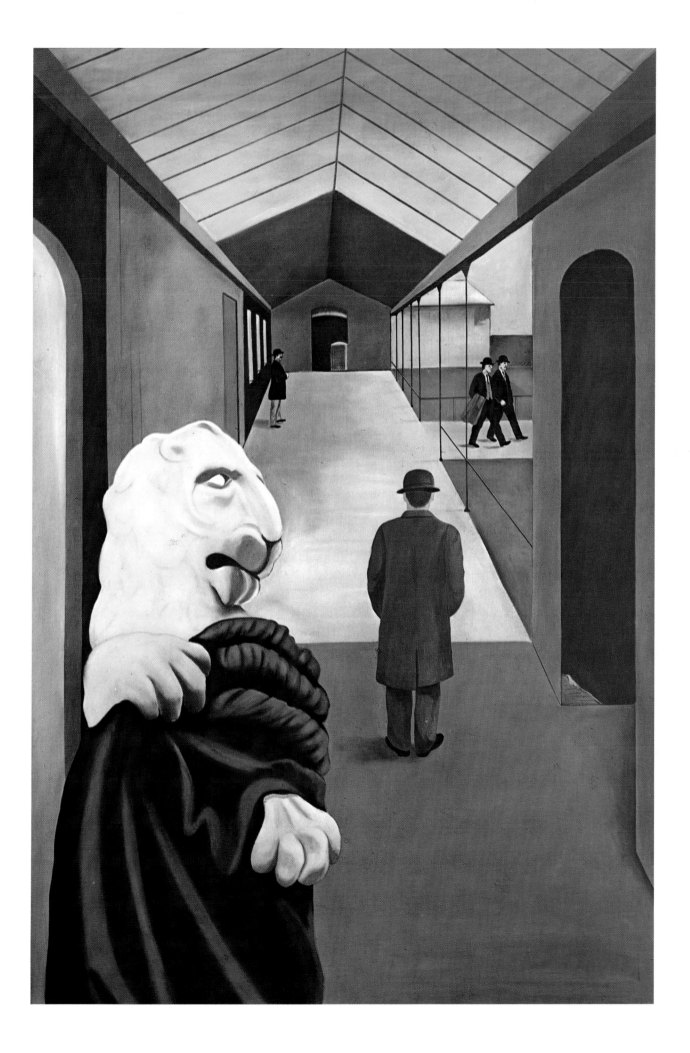

JOHN ARMSTRONG (1893-1973)

Dreaming Head

Tempera on wood, 47 x 78 cm. 1938. London, Tate Gallery

Fig. 35
JOHN BANTING
Conversation Piece

Tempera on paper,
52.4 x 47 cm. 1935.
London, Tate Gallery

John Armstrong joined the English avant-garde group Unit One in 1933 and his work subsequently became Surrealist in character. *Dreaming Head* reveals the central Surrealist preoccupation with dreams and especially dreaming women: Armstrong has written that in his pictures 'women and flowers express states of love'.

John Banting studied in Paris in 1922 and in 1930 took a studio there. He met André Breton and other leading figures, and contributed to the 1936 International Surrealist Exhibition. *Conversation Piece* (Fig. 35) is closely related to a drawing in Banting's satirical *Blue Book of Conversation* (eventually published in 1946), where it accompanied a dialogue between 'Lady Turquoise Tuckroe' and 'Lady Diamond Lit'.

Apart from Henry Moore (see Introduction and Fig. 10) it was F. E. McWilliam who produced the most compelling purely sculptural works of English Surrealism. *Eye, Nose and Cheek* (Fig. 36) is one of a series of bizarre carvings known as *The Complete Fragment,* of which the artist wrote: 'These carvings are mostly part or parts of the head greatly magnified and complete in themselves. They concern the play of solid and void, the solid element being the sculpture itself while the "missing" part inhabits the space around the sculpture.'

Fig. 36
F. E. McWILLIAM
Eye, Nose and
Cheek

Stone sculpture,
89 x 87 x 28.5cm. 1939.
London, Tate Gallery

EDWARD BURRA (1905-76)

John Deth

Gouache, 55.9 x 76.2 cm. 1932. Private Collection

One of the most distinctive and individual voices in modern British art, Edward Burra exhibited regularly with the Surrealists in London and Paris between 1936 and 1940. His relation to Surrealism is most apparent in works like *John Deth,* which reveal the strong and persistent vein of macabre fantasy that runs through his work.

About 1929-30 Burra made a small group of collages of which *Keep Your Head* (Fig. 37) is one. The use of the motor-car engine (thought by the artist to be a Rolls-Royce) suggests a Dada influence, rare in British art. In 1930 Burra wrote to his friend Barbara Ker-Seymer about these collages: 'Thank you for the 2 daintie pc's they will be so useful for my new pictures we never bother to paint in this part now we just stick on things instead. I have such a twee one started of 2 ladys walking along with pieces of motor engine for heads . . . ' (artist's own spelling and punctuation).

Fig. 37
EDWARD BURRA
Keep Your Head

Collage, 60 x 60cm. 1930.
London, Tate Gallery

The Hanged Man

Oil on canvas, 97 x 130 cm. 1942. Basel, Galerie Beyeler

Matta was born in Chile, studied architecture at Santiago University and moved to Paris in 1933. From 1934 to 1937 he worked in Le Corbusier's Paris office. In 1937 he began to show his drawings to a few painters – first Picasso, apparently, then Dali; through Dali he also met the writer André Breton, who immediately bought two of his drawings. Matta became a member of the Surrealist group and began to paint using 'automatic' techniques. He soon developed a vision of biomorphic and cosmic elements in a strange, misty and labyrinthine space which has a compelling force as a representation of the inner realm of the mind. His art came to its full maturity after he moved to New York in 1939; there he met Jackson Pollock among others and encouraged him in the use of the automatic techniques that were to lead to Abstract Expressionism (see Introduction).

The Hanged Man is an early example of Matta's mature style. Like many Surrealists he was deeply interested in magic and the occult and this title comes from the tarot card of that name. Sketches in Matta's notebook reveal that the large form on the left of the painting derives ultimately from an image of a foetus in the womb.

ROBERTO MATTA (b. 1912)

The Vertigo of Eros

Oil on canvas, 196 x 252 cm. 1944. Collection, The Museum of Modern Art, New York. Given anonymously

One of the best known of all Matta's paintings. The American art historian W. S. Rubin wrote of this painting: '[it is] the most profound of Matta's works and the central image of his *oeuvre*. This is the cosmic Matta who, in the evocation of infinite space, suggests simultaneously the vastness of the universe and the profound depth of the psyche. The title relates to a passage in Freud in which he locates all consciousness as falling between Eros and the death instinct – the life force and its antithesis. Afloat in a mystical light which emanates from the deepest recesses of space, an inscrutable morphology of shapes suggesting liquid, fire, roots and sexual parts stimulates an awareness of inner consciousness such as we trap occasionally in revery and dreams.'

ROBERTO MATTA (b. 1912)

Black Virtue

Oil on canvas, triptych, overall 76.5 x 182.5 cm. 1943. London, Tate Gallery

Black Virtue was painted shortly before *The Vertigo of Eros* (Plate 47); the artist has said he cannot remember the exact significance of the title and it may even refer to the so called virtue of killing the enemy. (He and his friends were extremely anti-Nazi at this period.) Certainly the predominance of black in this painting gives it a strong feeling of death. However the biomorphic forms in the central panel strongly suggest references to the female sexual parts and the undoubted erotic atmosphere of the painting is reinforced by Matta's use of a particular pink with the black. In his celebrated erotic tale *The Story of the Eye* (1928) the Surrealist writer Georges Bataille describes a girl's pudenda as 'sa chaire rose et noire' (her pink and black flesh). There are evident discontinuities between the three panels of this triptych and Matta is here using something of the collage technique of bringing together disparate realities. At this date he is known sometimes to have painted with existing parts of his pictures covered up and it is possible that the three parts of *Black Virtue* were done independently of each other.

The Armenian-born American painter Arshile Gorky played a crucial role in the evolution of automatic Surrealist painting towards Expressionism. About 1944-5 he evolved a freer, more fluid and abstract biomorphism than had been seen before. Of these works André Breton wrote in 1945 (and with remarkable prophetic vision): 'Gorky's art . . . provides the proof that . . . an absolute purity of means, in the service of an unquenchable freshness of feeling and a limitless gift for self-expression, can make it possible to break away from the rut of the known and point the way to freedom with a flawless arrow of light.' *The Liver is the Cock's Comb* (Fig. 38) remains Gorky's most famous work and was described by Breton as 'marvellous . . . a great gateway'.

Fig. 38
ARSHILE GORKY
The Liver is the
Cock's Comb

Oil on canvas,
183 x 149 cm. 1944.
Albright-Knox Art Gallery,
Buffalo, New York. Gift of
Seymour H. Knox

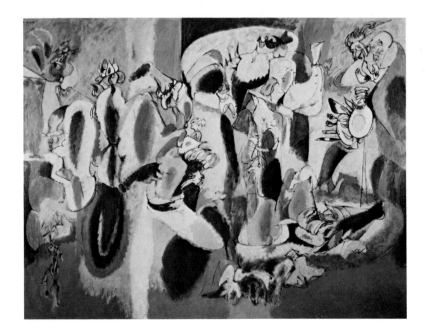

PHAIDON COLOUR LIBRARY
Titles in the series

FRA ANGELICO
Christopher Lloyd

BONNARD
Julian Bell

BRUEGEL
Keith Roberts

CANALETTO
Christopher Baker

CARAVAGGIO
Timothy
Wilson-Smith

CEZANNE
Catherine Dean

CHAGALL
Gill Polonsky

CHARDIN
Gabriel Naughton

CONSTABLE
John Sunderland

CUBISM
Philip Cooper

DALÍ
Christopher Masters

DEGAS
Keith Roberts

DÜRER
Martin Bailey

DUTCH PAINTING
Christopher Brown

ERNST
Ian Turpin

GAINSBOROUGH
Nicola Kalinsky

GAUGUIN
Alan Bowness

GOYA
Enriqueta Harris

HOLBEIN
Helen Langdon

IMPRESSIONISM
Mark Powell-Jones

**ITALIAN
RENAISSANCE
PAINTING**
Sara Elliott

**JAPANESE
COLOUR PRINTS**
J. Hillier

KLEE
Douglas Hall

KLIMT
Catherine Dean

MAGRITTE
Richard Calvocoressi

MANET
John Richardson

MATISSE
Nicholas Watkins

MODIGLIANI
Douglas Hall

MONET
John House

MUNCH
John Boulton Smith

PICASSO
Roland Penrose

PISSARRO
Christopher Lloyd

POP ART
Jamie James

**THE PRE-
RAPHAELITES**
Andrea Rose

REMBRANDT
Michael Kitson

RENOIR
William Gaunt

ROSSETTI
David Rodgers

SCHIELE
Christopher Short

SISLEY
Richard Shone

**SURREALIST
PAINTING**
Simon Wilson

**TOULOUSE-
LAUTREC**
Edward Lucie-Smith

TURNER
William Gaunt

VAN GOGH
Wilhelm Uhde

VERMEER
Martin Bailey

WHISTLER
Frances Spalding